In
Character

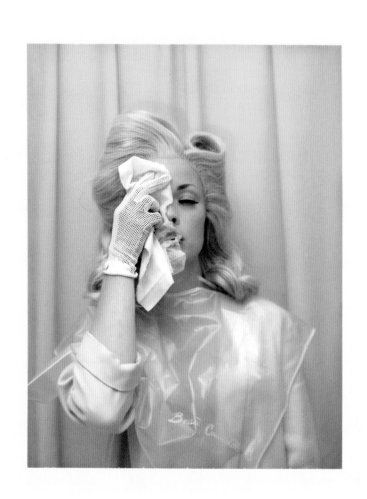

Anja Niemi

In Character

176 illustrations

 Thames & Hudson

CONTENTS

THE WOMAN WHO NEVER EXISTED, OR ON THE SUBJECT
BY MAX HOUGHTON

The woman who never existed takes many forms. Once, she appears as
an image in a mirror carefully positioned on a dressing table. Her face is
entirely covered by hair, as though a wig has been misaligned, the face
mistaken for the back of the head. Her body so evokes a chair as to invite the
possibility of taking a seat. Draped green curtains imbue the scene with an
acute performativity. In this seat of contemplation, or judgment, or power,
the sitter is neither troubled by the action of standing, nor occupied with
the sensual repose of sleeping. Becoming chair, she sits. We are witness
only to her reflected image; the subject has gone missing, while the viewer
occupies the absence, this place of dissimilitude, as well as taking the place
of the image's creator. More than the faceless character, it is the illusory
power of the photograph that takes centre stage in the opening image of
Do Not Disturb, the first series presented in this monograph.

Anja Niemi creates a form of photographic self-portraiture that
complicates our subjectivity in a way that recalls the literary genre of
autofiction, in which autobiography and fiction fuse, creating uncertainty
around the boundary between character and narrator. Even in traditional
narrative fiction, the sense of 'being-two-to-speak' is pervasive; the
relationship between the author and the narrator, or the narrator and other
characters, is always stranger, more telepathic, than we might first imagine.
The dichotomy of subject and author is destabilized by such modes, in
which the concept of the self is bifurcated. Niemi utilizes this technique in
her chosen medium to enable a series of encounters with an always divided
self. Silently, her photographs pulse to the refrain '*je est un autre*', as so
eloquently conveyed in Rimbaud's grammatical slippage.

Yet within Niemi's oeuvre, there is no real sense that we are looking
at any 'self' that defines the author. In many ways, her imagery is better
situated in the *tableau vivant* genre of the nineteenth century, which
intended to keep classical painting alive, though transformed. The creation
of 'living pictures' was a popular parlour game in Victorian high society,
and infused the emerging photographic practice with its emphasis on
dressing up and metamorphosis. In 1874, Julia Margaret Cameron created
an extraordinary series of tableaux to illustrate Tennyson's narrative poems
about Arthurian legend, *Idylls of the King*, and the lyrical richness of her
staging, borrowing much from pre-Raphaelite painting, succeeded in taking
photography to a realm it had yet to occupy: that of art. Almost a century

and a half later, photographic tableaux are more reminiscent of film stills, moments of highly controlled anticipation, and it is precisely into this space that Niemi enters the picture.

A comparison with Cindy Sherman, particularly her seminal *Untitled Film Stills*, would seem to follow naturally, but her images are not a direct antecedent to Niemi's work. Part of a new generation, Niemi's characters are the kind of women beloved of, and objectified by, the film directors who shaped her own sense of aesthetics – the surrealist eyes of Lynch, Hitchcock and Bergman in particular. Early in Sherman's career, when the majority of her characters referenced the idealized women of the 1950s, her images raised the question of whether these characters – before the (fake) blood and (fake) vomit that would follow – reinforced the male gaze. Niemi's characters may well have been formed by the cinematic male gaze, but in her own hands, the only time the camera lingers longingly over their bodies is when they are shaped like missiles, in the many unexpected poses that punctuate her narratives. By turns rigid and graceful, the female body is reclaimed as a means for experiencing emotion, rather than an object upon which (male) pleasure might be enacted.

In the transient privacy of the hotel room of *Do Not Disturb*, Niemi stages her characters in a series of darkly humorous, or simply dark, gestural poses: swallow-diving onto a bed; presenting her head for packing into a suitcase; lying submerged and unresponsive in a bath, or prone in a hotel corridor. 'Room 21' in this series emanates from another mirror, the trifold kind that my mother kept on her dressing table, and that as a child I would angle on the left and right sides so I could see myself – my selves, my imaginary selves – repeating to infinity. Niemi uses the triptych to stage a disappearance. One fragmented body part. Another. An empty bed. All that remains is her absence. Photography is a useful medium for an exploration of absence and presence, in that the represented form is assumed to refer to something or someone 'real'. Niemi artfully plays with this idea, positioning the photograph as a kind of absented presence throughout her work.

These collisions of subject and object, of absence and presence, lead us into the territory of what Freud called 'the uncanny', which is as much an aesthetic strategy for Niemi as is her use of beauty. Freud's sense of the *unheimlich* had multiple definitions, originating in a sense of the unfamiliar (or 'unhomely'), but also referring to something that ought to be kept secret, even from – in fact, especially from – the self, but has been inadvertently revealed. In *Starlets*, we are once again confronted with a reflection; from out of a vanity mirror, a woman in a blue dress stares straight ahead, directly into the camera. To the left of this apparition is

a disembodied arm, its white-gloved hand reaching for the telephone. From the position of the arm, it seems clear that the rest of the body – assuming there is one – is on the floor, unable to stand. The arm is clothed in the same blue fabric as the woman in the mirror, but impossible to align with her reflected image. She is doubled.

Throughout *Starlets* and in her next series, *Darlene & Me*, Niemi creates ever more purposeful acts of doubling that animate the self's internal strife. Over and over, identical characters are pictured in conflict, as though one self is wounded and the other is the aggressor. Freud theorizes that the double plays two roles in relation to our sense of self: first, as part of the child's desire to be multiple, before the ego is established during primary development; and then as the superego, the critical voice that inhabits each of us, as a function of self-observation. When the double returns in its second incarnation, it enforces a return to a primitive state, rendering the double a representation of every thought that is unacceptable to the ego. Reminiscent of the self-destructive tendencies of Madeleine/Judy – both played by Kim Novak – in Hitchcock's *Vertigo*, and Elisabet/Alma, whose boundaries blur bewitchingly in Bergman's *Persona*, the level of violent thought at work between the conflicted selves in *Starlets* and *Darlene & Me* spells double trouble.

Freud articulated his ideas about the uncanny and the double following a close reading of the literary works of E. T. A. Hoffmann, who repeatedly returned to the concept of the automaton in his writing. Hoffmann's most memorable female automata, who we meet in the terrifying story of *The Sandman*, was Olympia, the 'beautiful statue' with whom Nathanael fell in love, thus spurning his tender but intellectually challenging fiancée Klara. Yet it is at Klara that Nathanael aims the accusation 'You damned, lifeless automaton!', in protest at her attempt to disabuse him of his belief in the Sandman's nocturnal desire to steal his eyes (for Freud, a symbol of castration). Troubled Nathanael, descending into some kind of madness, believes in Olympia's love because of her 'yearning looks' and professes his adoration thus: 'You profound spirit, reflecting my whole existence.' It is never clear which, if any, of the female characters is real, and this is how the story unleashes its uncanny logic, forcing us to question the simple binary of the certainty of the flesh and lifelessness of the machine. The faces of Niemi's characters – Darlene, the Starlet, the Cowboy – are doll-like and expressionless in a way that masks any notion of self. Is their purpose to reflect *our* existence, to allow us to enter into the lives of others to better understand our own?

It is tempting to read Niemi's images as part of a solely gender-related discourse, though this would be a reductive interpretation of her work.

The characters in her photographs are indeed female, exclusively so, and – even more significantly – they are hyper-feminine, exaggerated versions of female icons. She is creating a performance of gender identity that would be familiar to a drag artist and, in so doing, she is able to pose her central question: of conformity. While Niemi is not performing drag per se, she is commanding a similar aesthetic, more usually appropriated by gay men. Her characters remind us that women perform femininity every day, to greater or lesser degrees. One is not born a woman; one becomes one. One is not born with rhinestone eyelashes, but one can acquire them. Or as RuPaul has it: 'You're born naked and the rest is drag.'

The act of transformation – also in common with drag – is vital to Niemi, who uses the photographic image specifically for that purpose, and not only to transform the self. She has an acute eye for the pattern and fabric of elaborate interiors, and how her characters will interact with them. There are parallels with how wallpaper was used as a symbol of a suffocating domesticity and encroaching madness in Charlotte Perkins Gilman's short story *The Yellow Wallpaper*. Gilman's female narrator, convalescing from a 'nervous depression', is advised by her husband, who is also her doctor, to rest, and is forbidden from writing so the rest-cure can work. Her only stimulation, therefore, is to analyse the yellow wallpaper in the bedroom to which she is confined. Over time, she becomes transfixed by it, and convinced that there is a woman trapped within. In an emotional frenzy, she tears and bites at the wallpaper, desperate to free the spirit – and herself. The story mirrors the author's real-life experience (though Gilman divorced her husband and continued to write), and its themes of isolation and control remain pertinent. Similarly, in at least two images by Francesca Woodman, an early influence for Niemi, the artist's soft, fragile body is engulfed by torn wallpaper and subsumed into the hard walls of the room. There is a sense that Niemi's tactics are similar, but that her motivation is to stage another disappearance, worlds away from dreary domesticity, and using her default setting: immaculate beauty. So ethereal is the woman who never existed that she becomes indistinguishable from the floral wallpaper in her exquisitely painted prison, for so it seems to become.

Niemi is at heart a storyteller, a creator of fictions. She crafts exquisite tableaux in which she can hide in plain sight. She draws on the familiar imagery of childhood games – the cowboy, the toy soldier – following a tradition in photography of constructing tightly controlled worlds in which fantasies can be carried out. Despite the doubles that permeate her work, despite the seven selves that constitute the Polaroid series *Short Stories* – or maybe precisely because of these phantom selves – there is a sense that Niemi's work operates as a poetics of isolation. Like butterflies pinned for

display by the very wings that gave them flight, the better to see their lifeless beauty, the existence of each character seems transient, though they are trapped in the photographic frame for posterity.

In her 1905 novel, *The House of Mirth*, Edith Wharton wrote of tableaux vivants: 'To unfurnished minds they remain, in spite of every enhancement of art, only a superior kind of wax-works; but to the responsive fancy they may give magic glimpses of the boundary world between fact and imagination.' There dwells the woman who never existed, maintaining her poker face at every attempt to define who or what or even whether she is... or is not.

ANJA NIEMI IN CONVERSATION
WITH MAX HOUGHTON

MH Self-portraiture as a genre encompasses many visual approaches. Because you are always 'in character', where do you see your work fitting into this mode?

AN I've thought about this a lot, and the more I think about it, the more perplexing I find it. I have been putting myself into my work for almost twenty years, but I'm still not sure if the images I create are strictly self-portraits; it certainly isn't how I think about them. As a young artist, I found myself adrift, with lots of ideas but no coherent way to express them. Being dyslexic with social anxiety seemed like a huge stumbling block at first. When I discovered photography, I started to realize that I could tell stories without words, and I could translate the ideas in my head into something tangible. The camera was a tool to turn my ideas into reality. I knew immediately that I had to control every element of the process myself in order to feel comfortable. So that's the original reason why I am present in my photographs. Of course, the practice has developed into something much more than I could ever have imagined.

Ingmar Bergman's *Persona* was groundbreaking for me in how it visualized matters that I wanted to express in my work. I found the way in which Elisabet and Alma blur and become inseparable captivating. I definitely see the character as one person, with an imaginary other self to whom she addresses her thoughts, and I love the silence within the film (Elisabet does not speak). It's as though she cannot keep on living up to the expectations placed upon her as an actress, as a mother, as a woman, and retreats into her own private world. She finds freedom in silence, but it finally becomes as terrifying as her captive life. The film really made me question what or who I could definitely say is my 'self'. If my work were a series of self-portraits, I would have to understand myself better than I do. I suppose you could say my images are an exploration of where my self begins – and therefore self-portraiture of a kind – but please do not ask me where it ends!

MH Can you describe further how *Persona* made such a strong impression on you, and how the ideas awakened in you by the film have manifested in your work, especially in the series *Darlene & Me*?

AN It was the combination of striking visuals – the slow movements of the camera over the faces, the way the screen splits into two – and the

INDEX

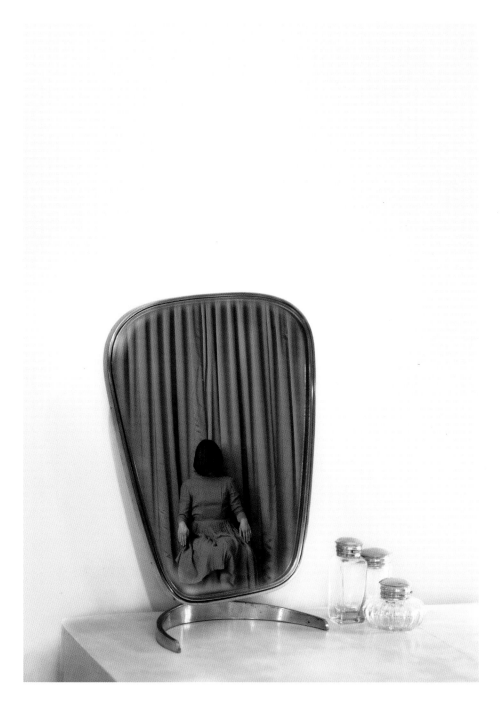

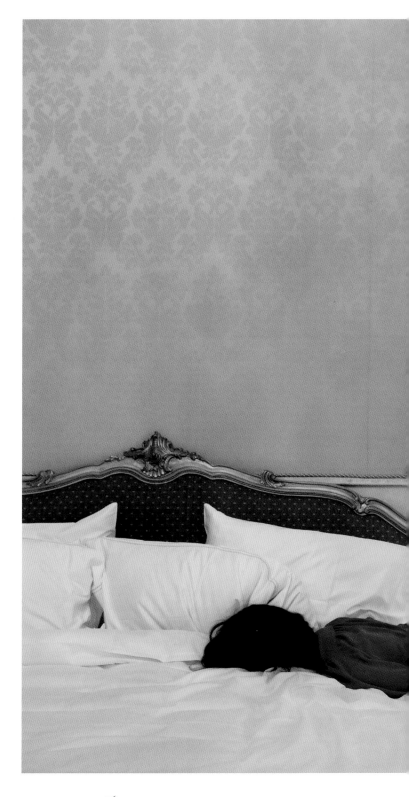

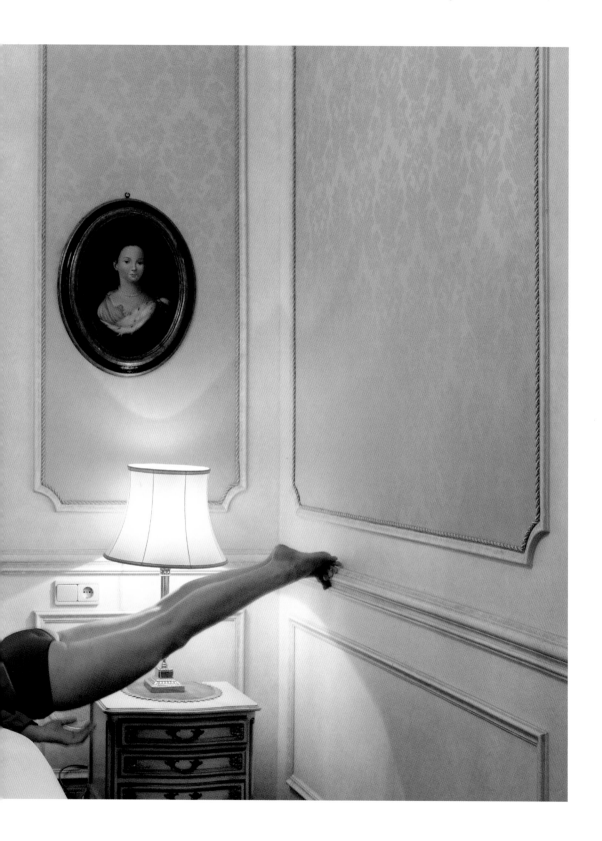

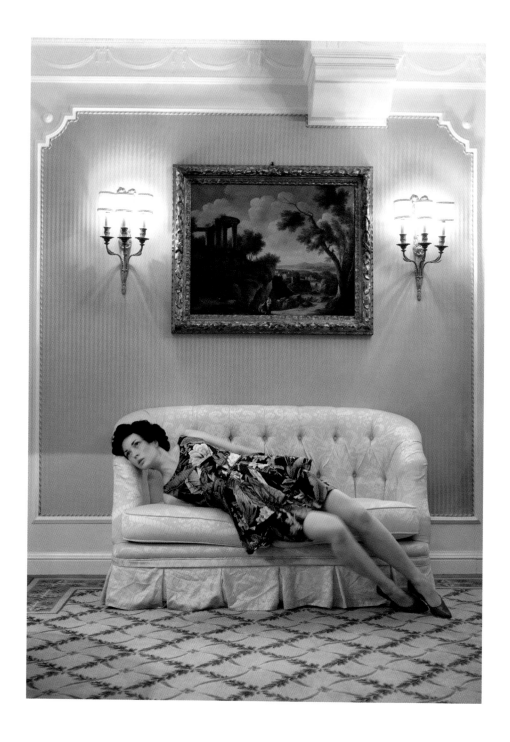

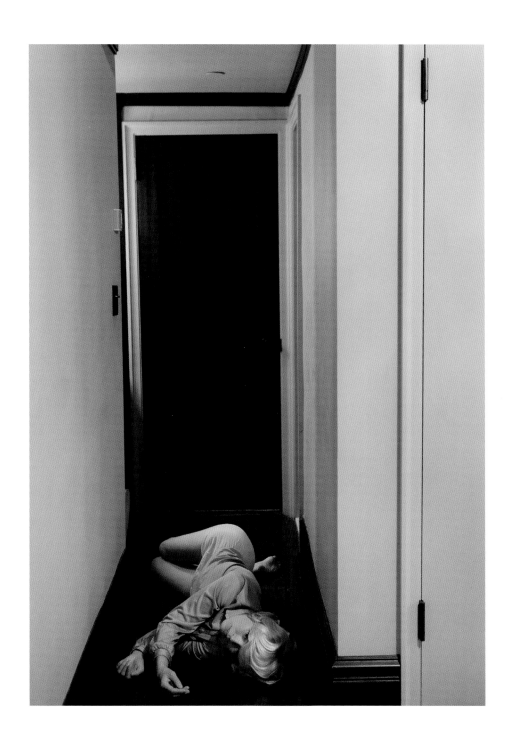

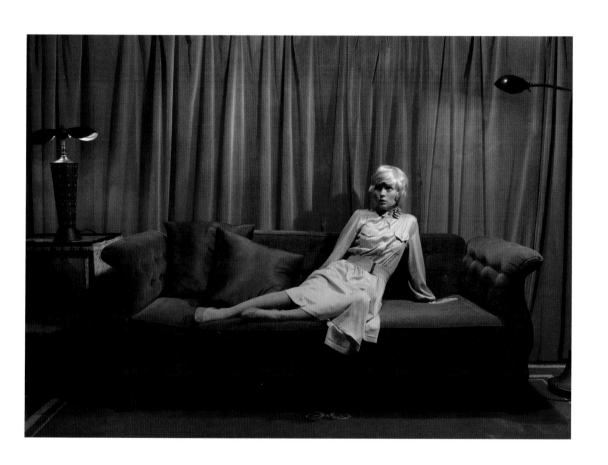

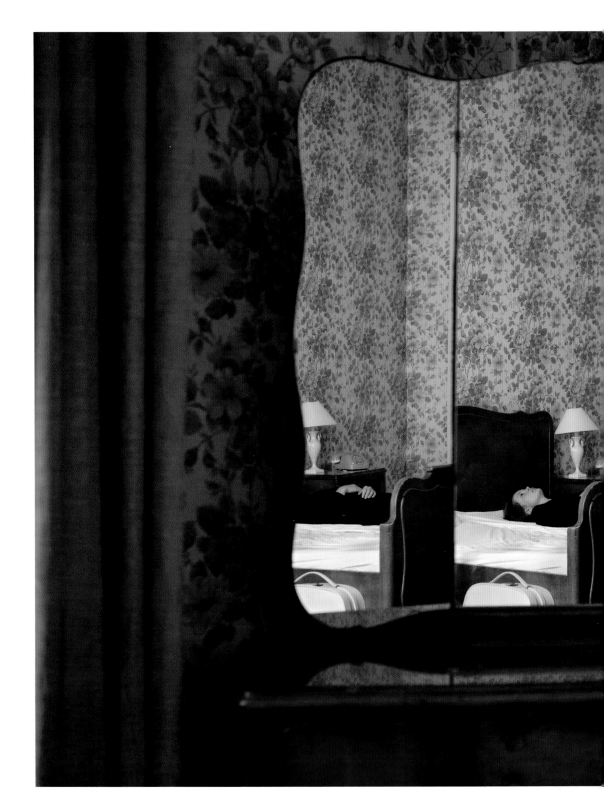

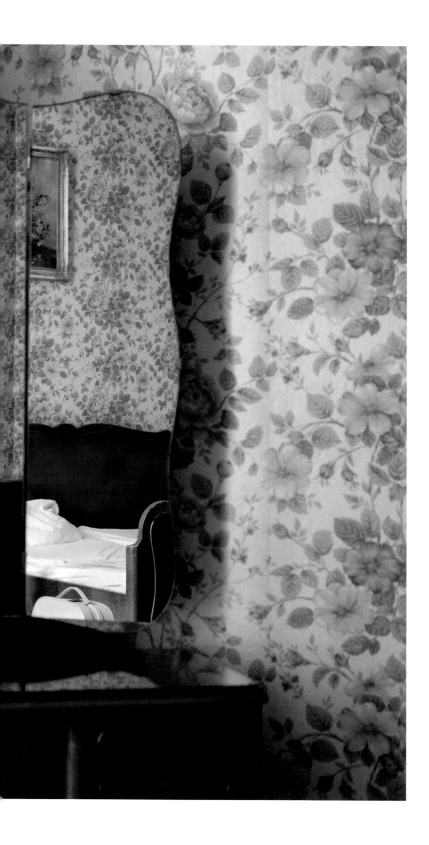

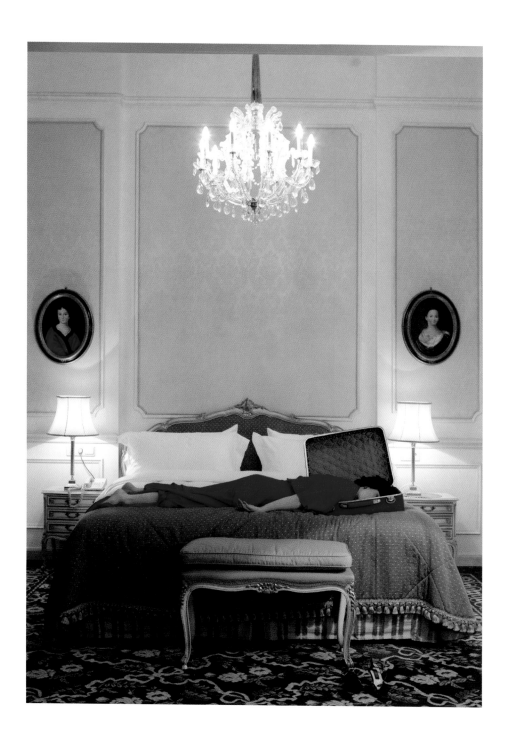

– II –

STARLETS

2013

INDEX

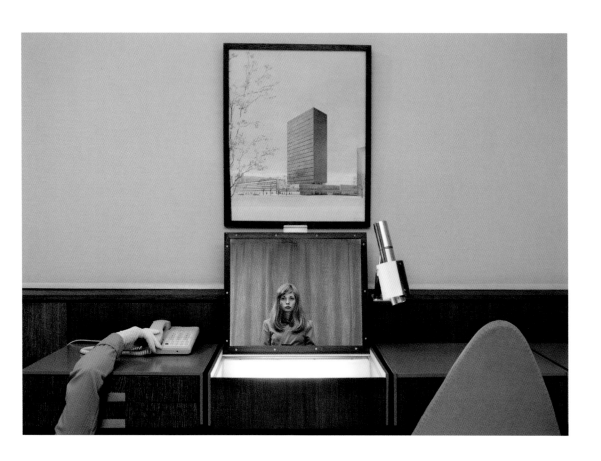

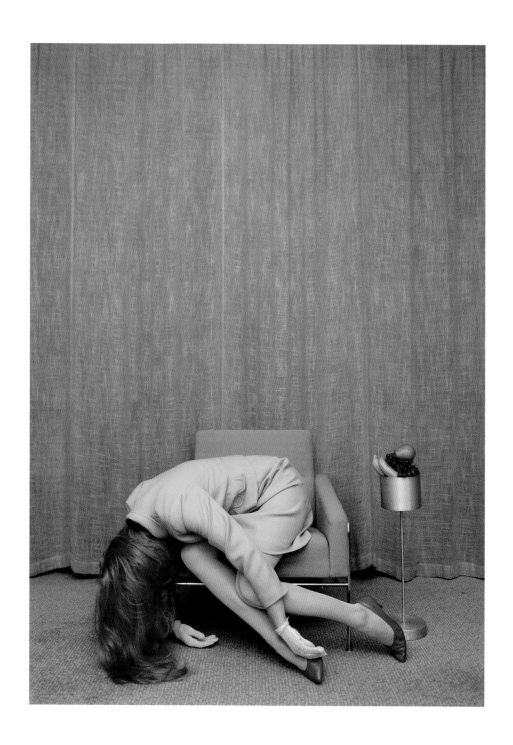

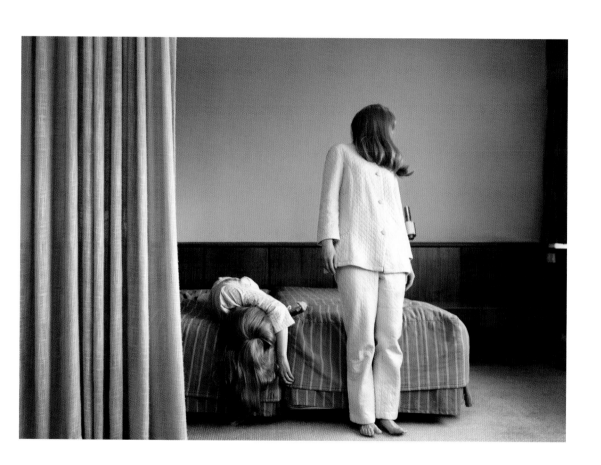

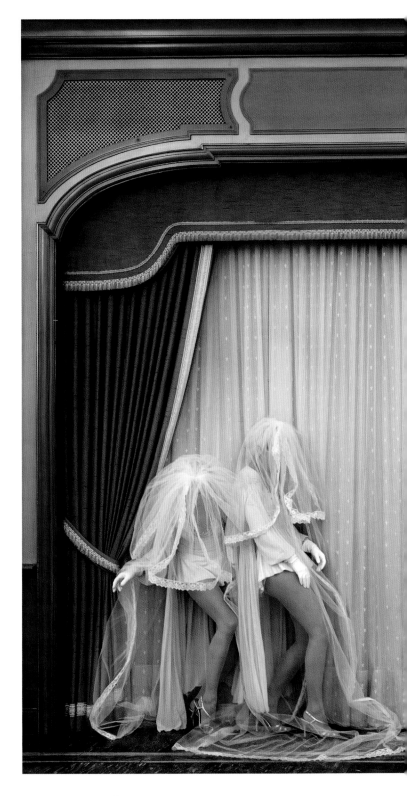

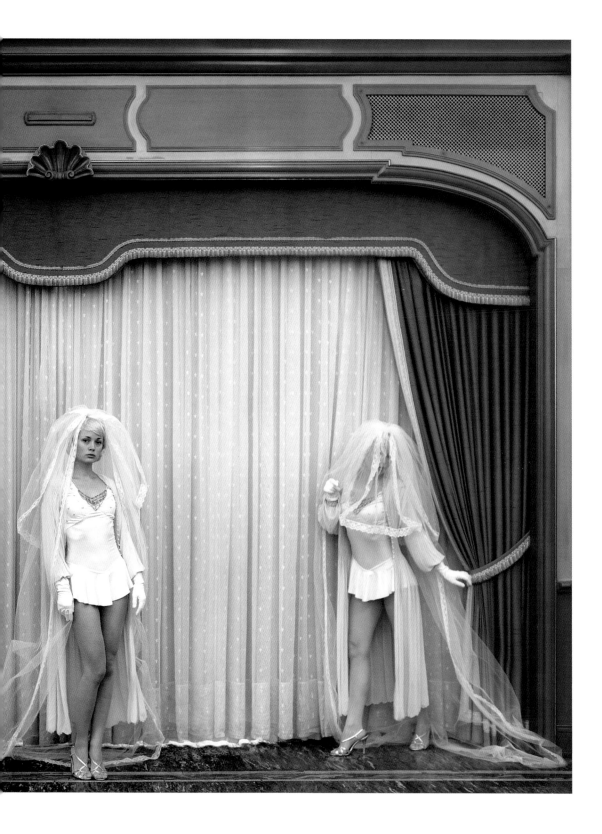

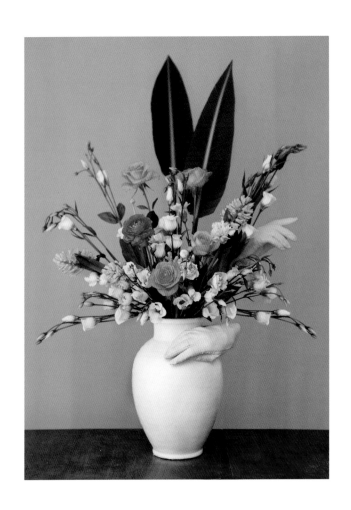

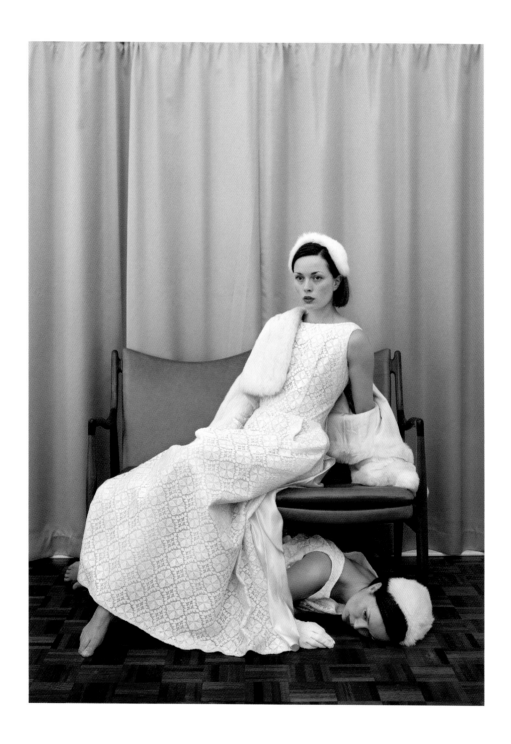

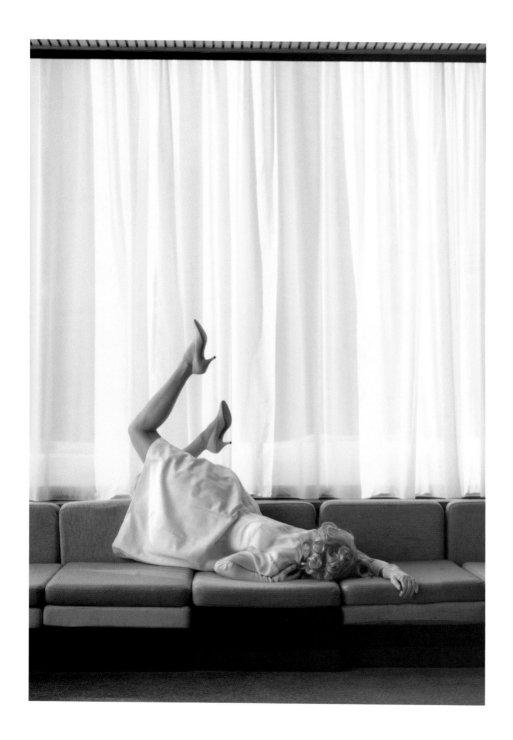

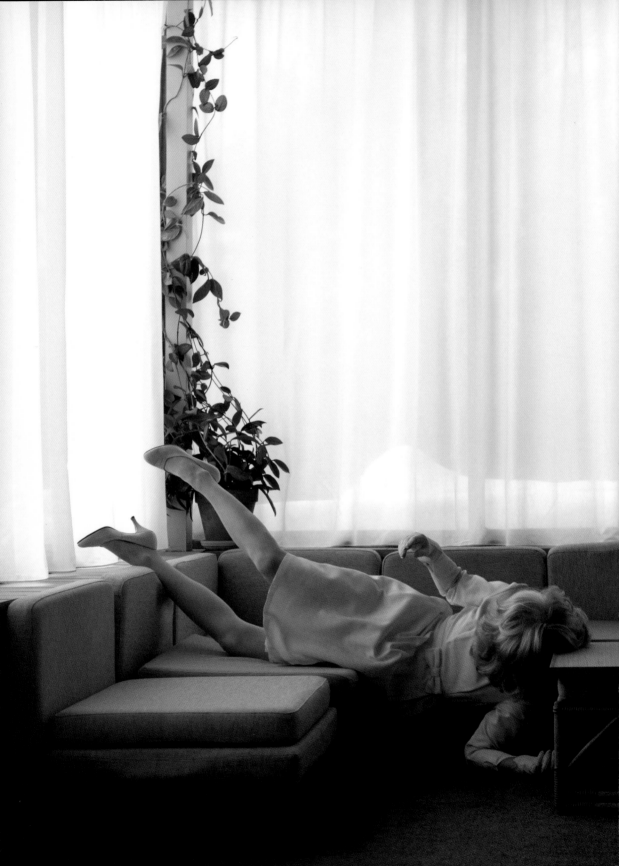

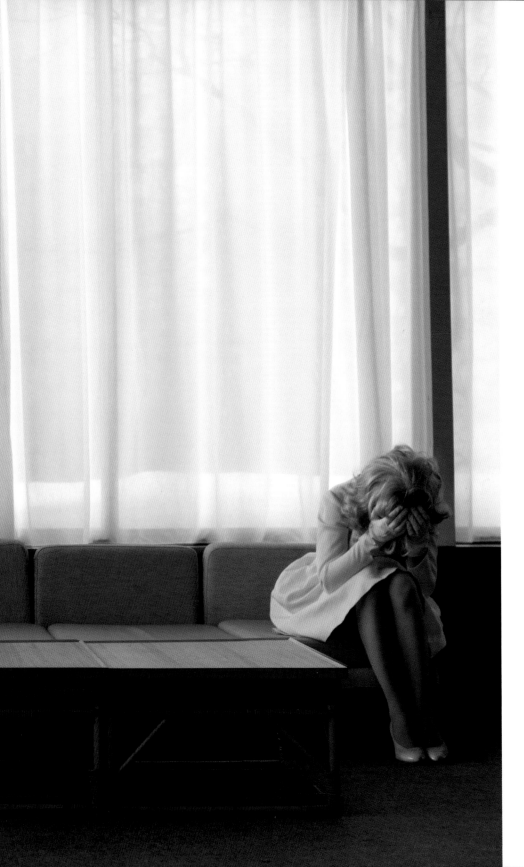

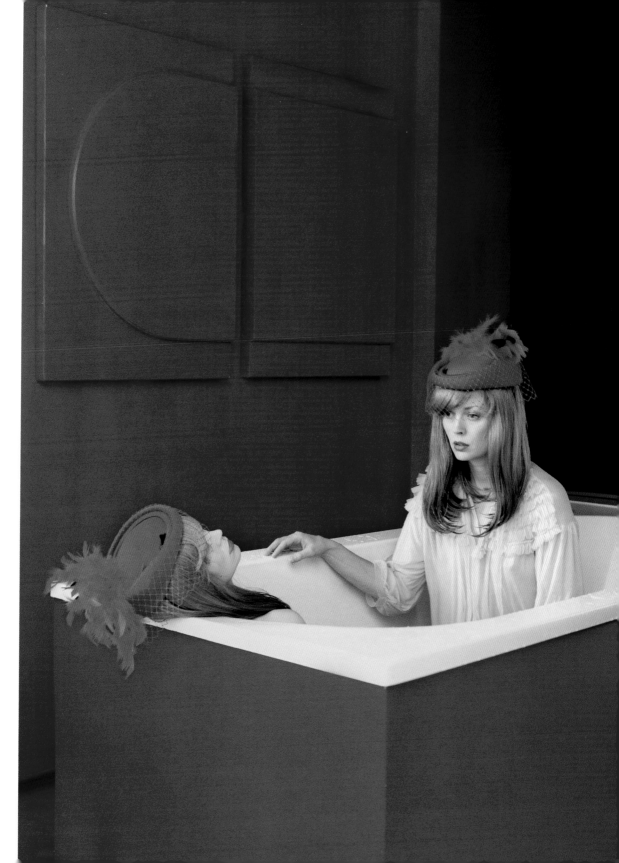

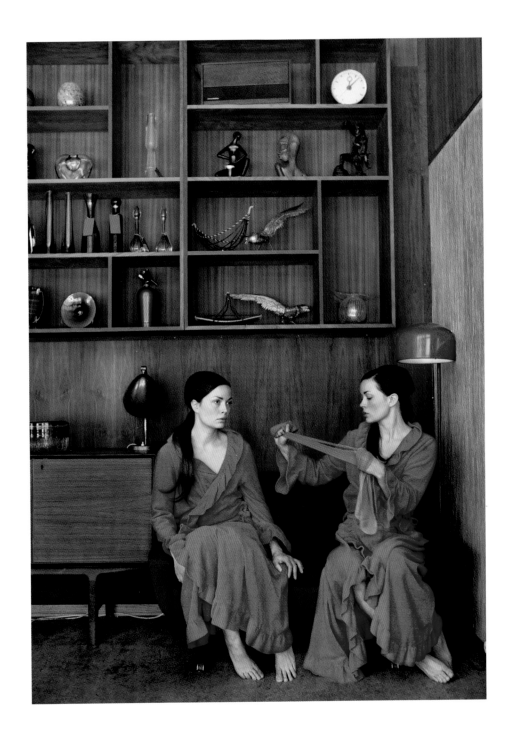

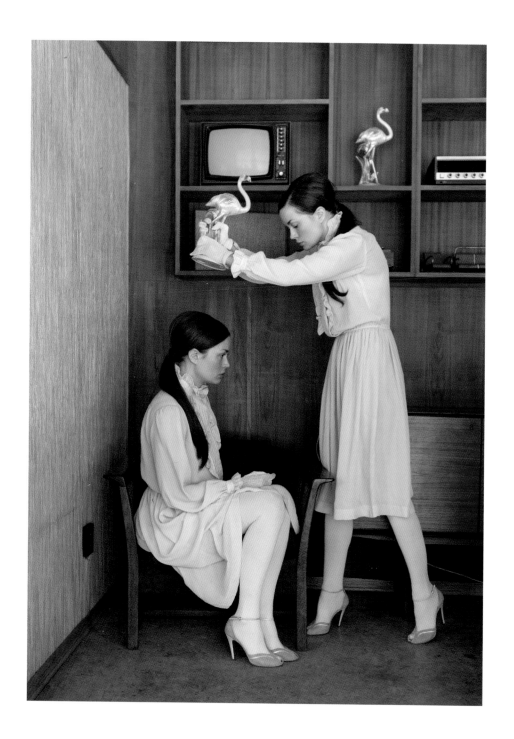

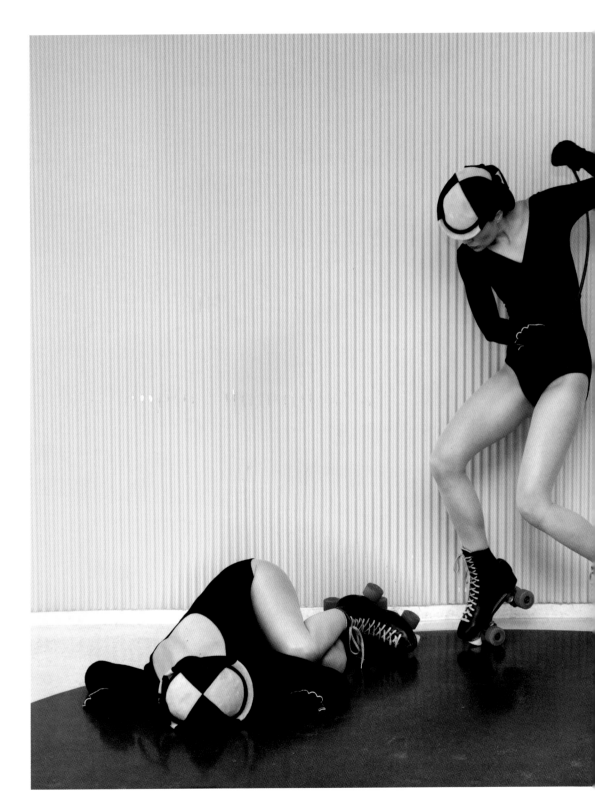

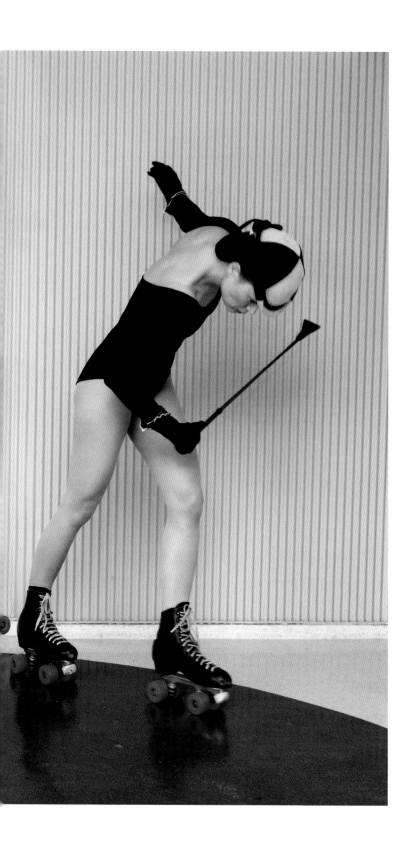

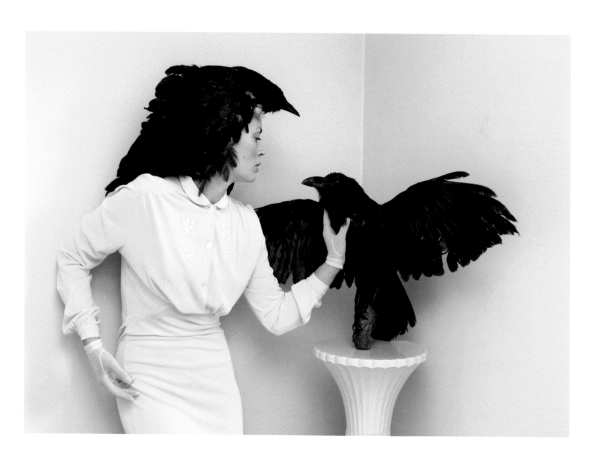

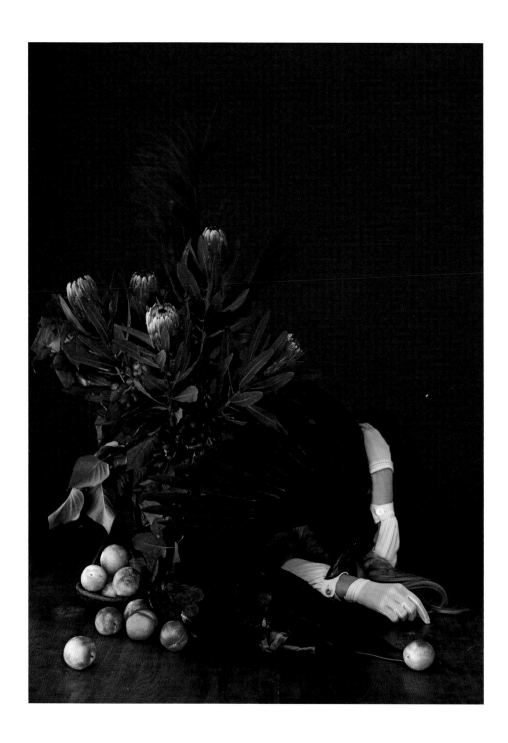

– III –

DARLENE & ME

2014

INDEX

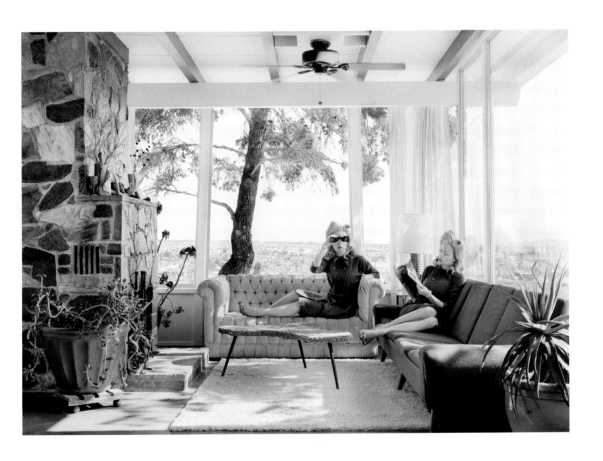

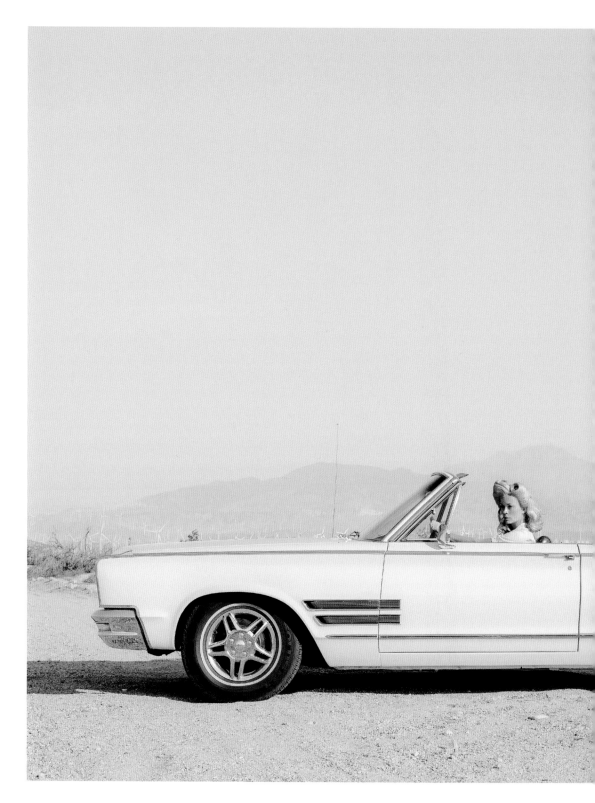

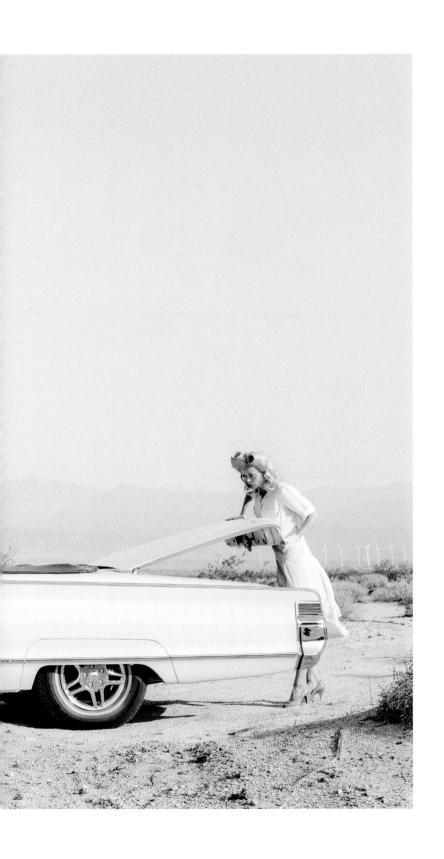

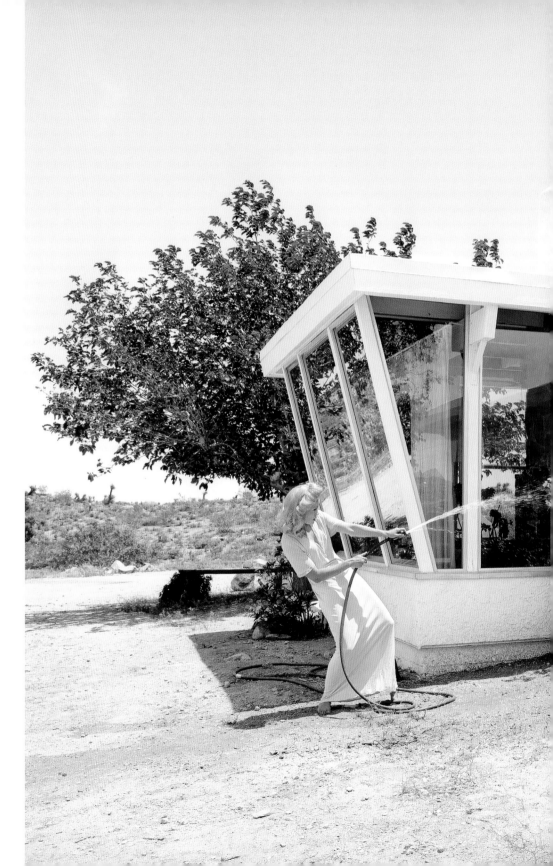

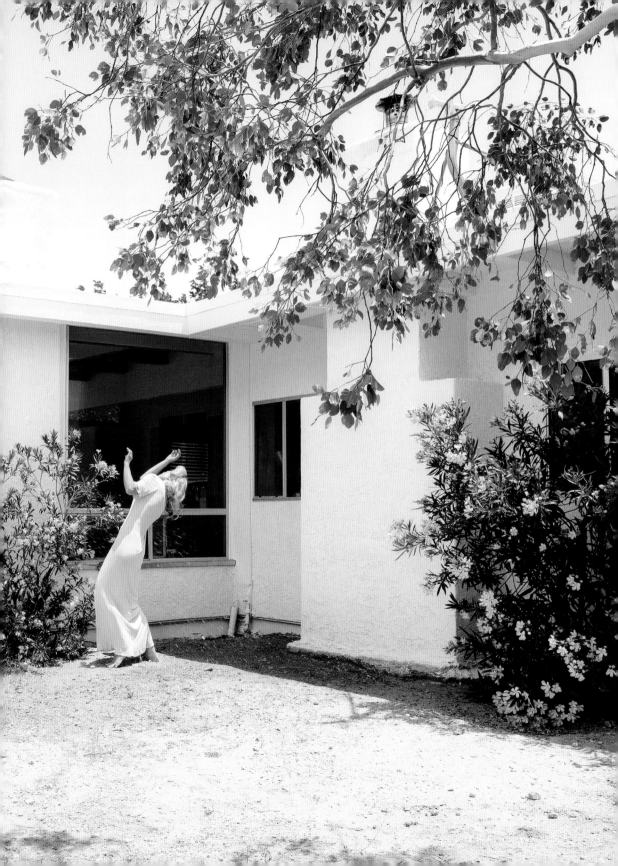

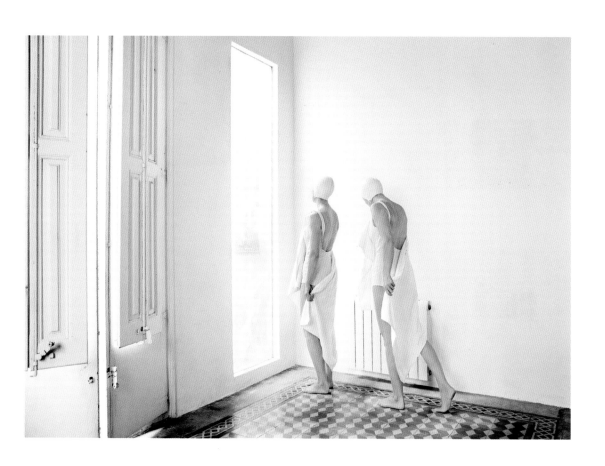

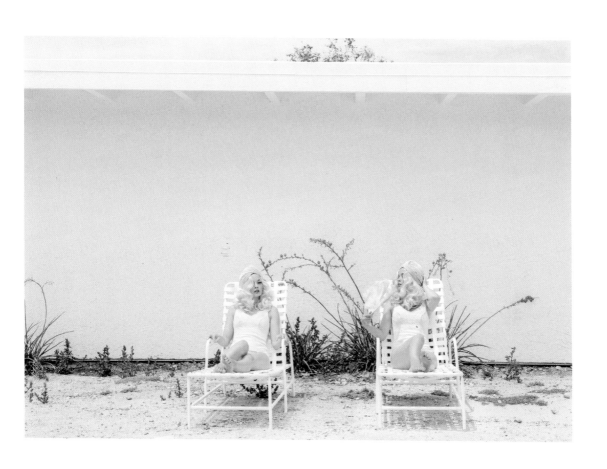

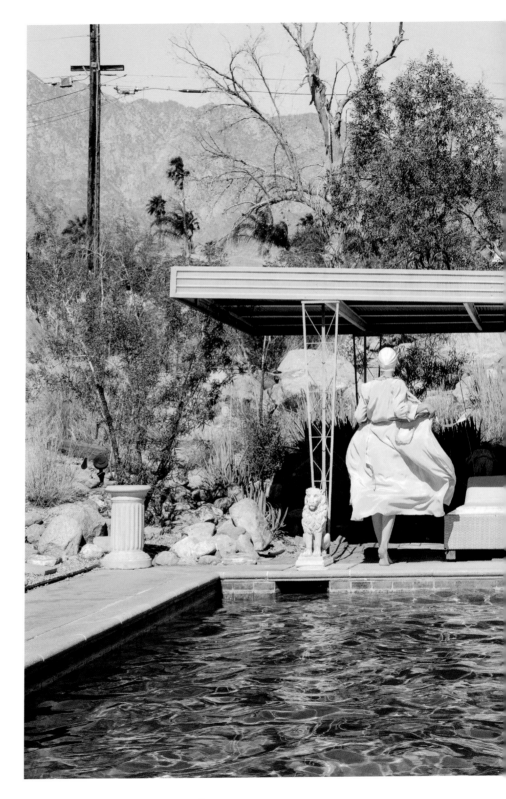

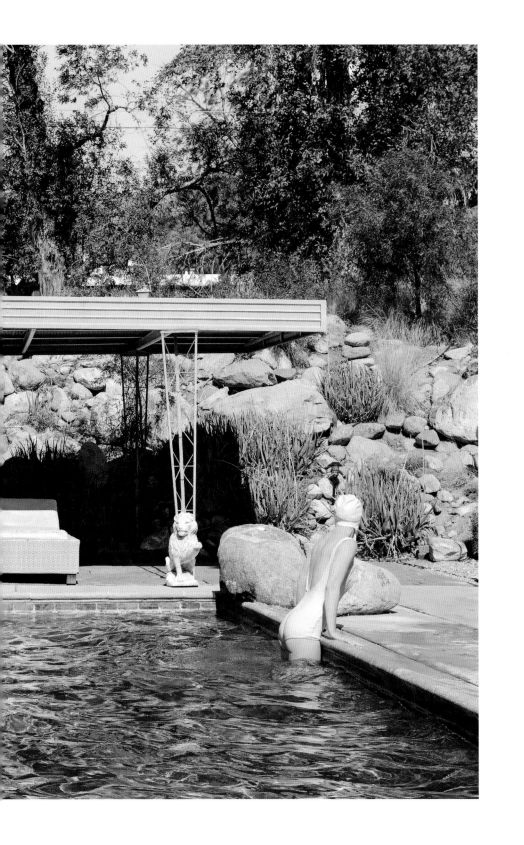

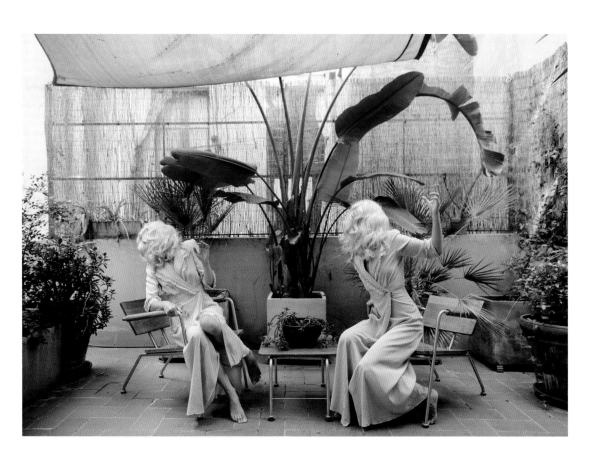

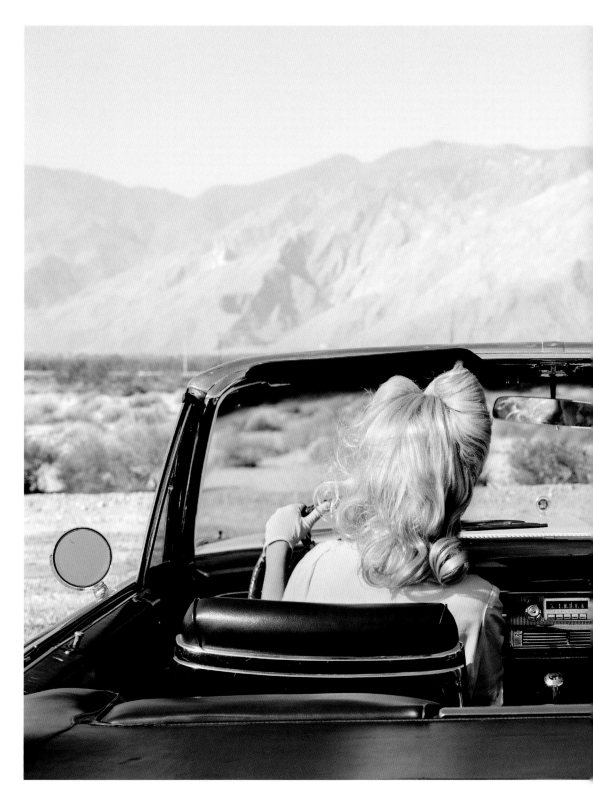

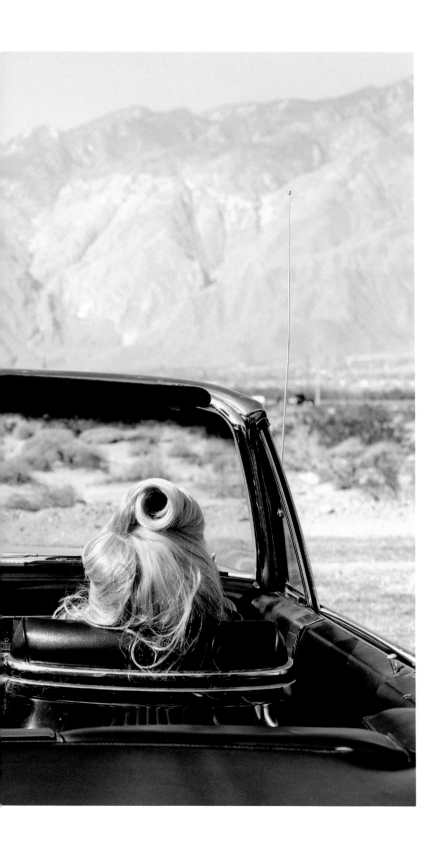

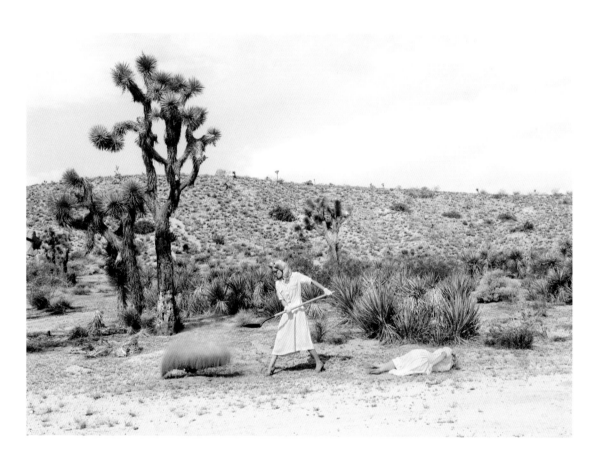

– IV –

SHORT STORIES

2016

INDEX

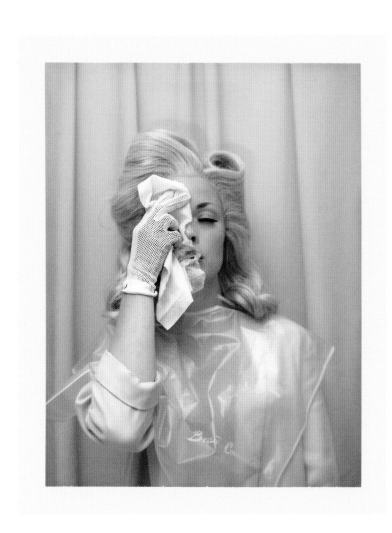

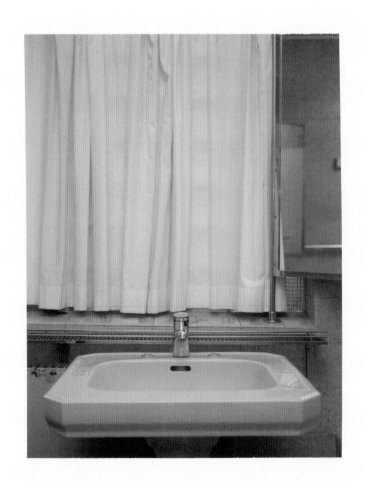

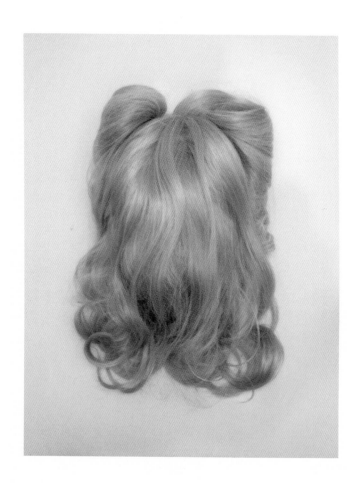

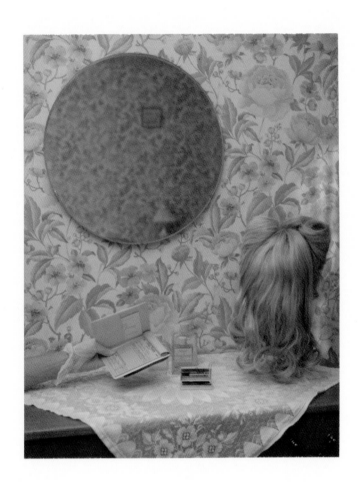

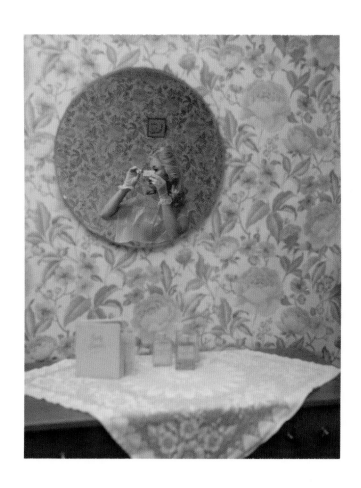

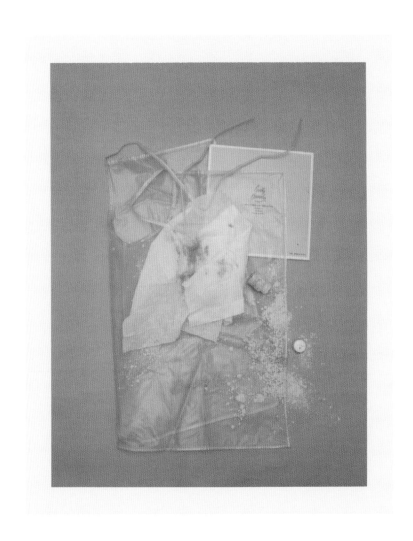

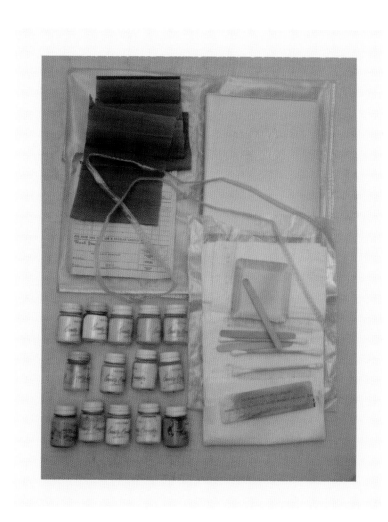

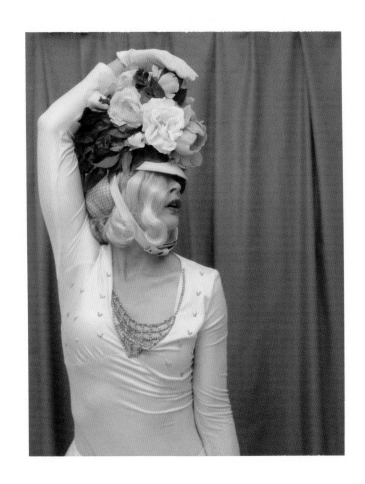

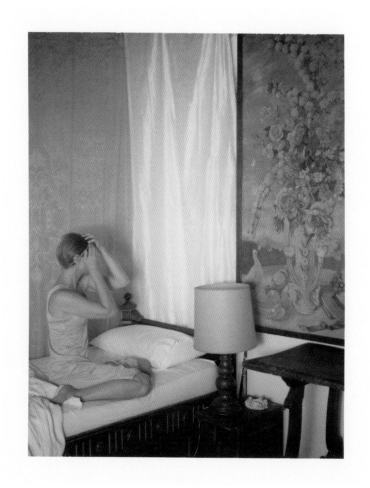

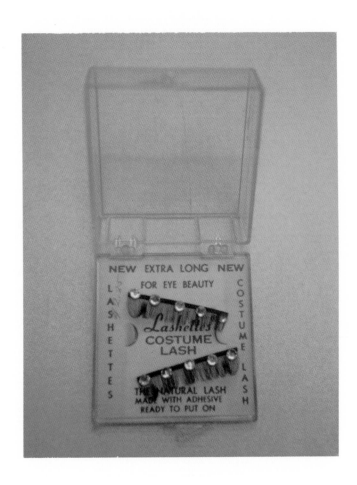

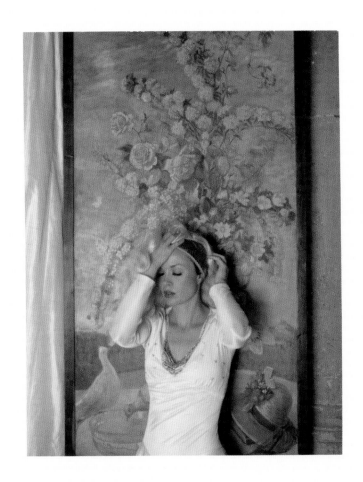

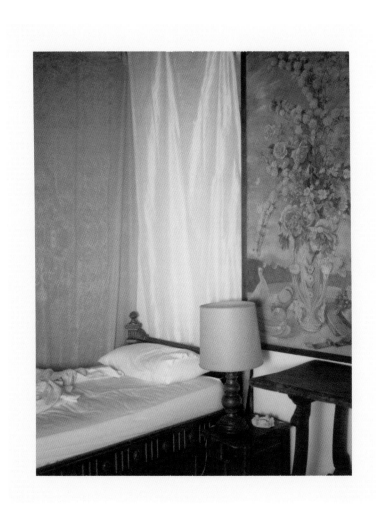

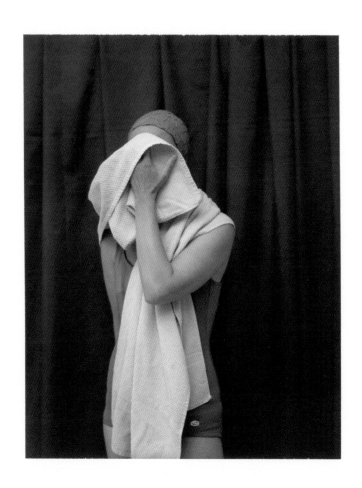

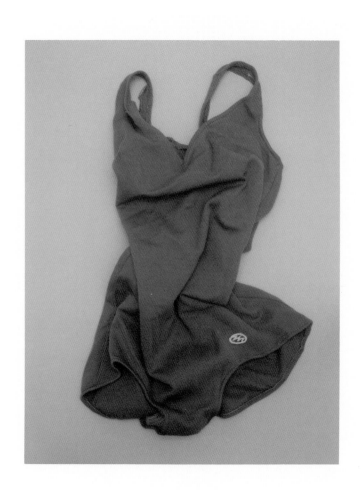

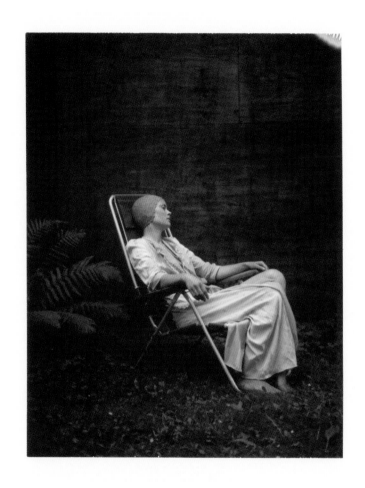

VISITOR FOR T
IN YEL

THE TETONS ABOUT 7 A.M.

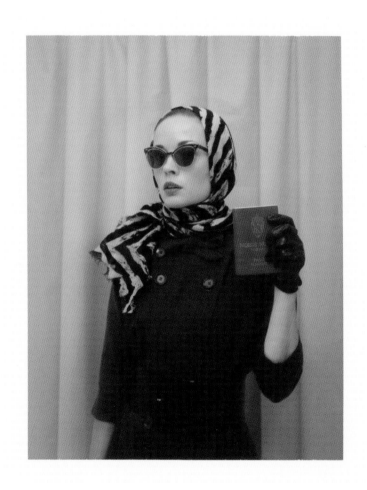

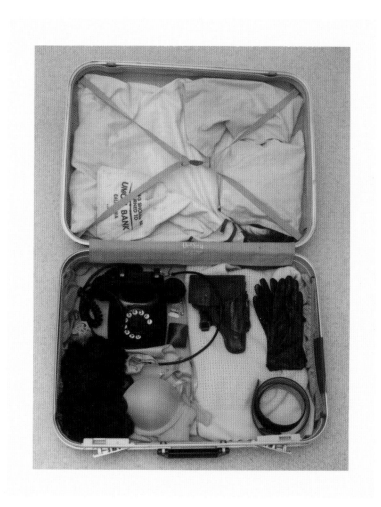

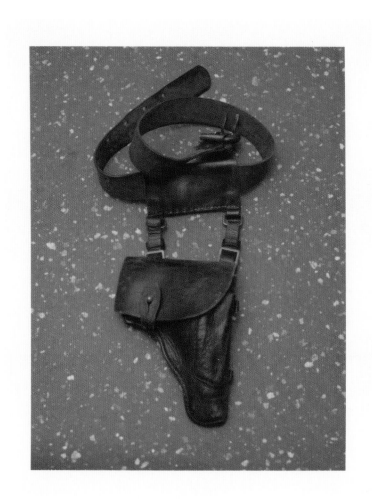

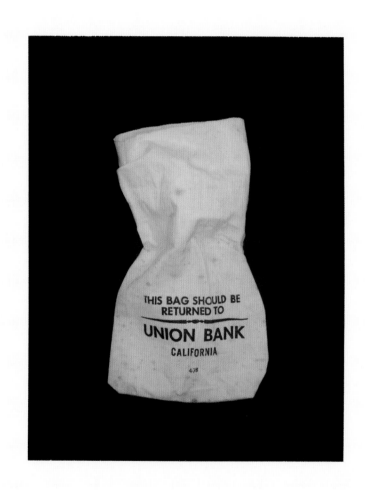

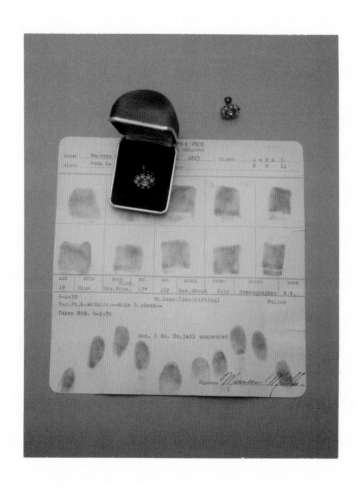

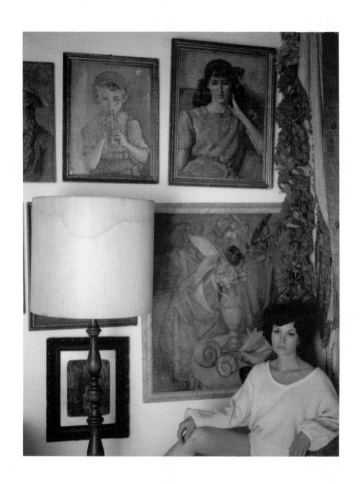

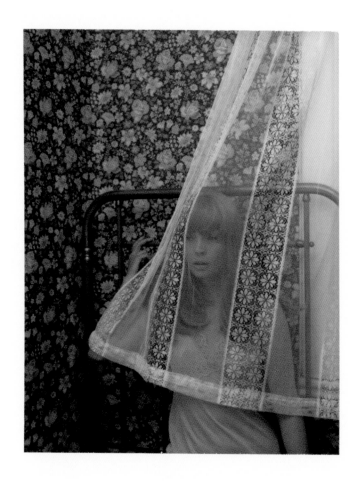

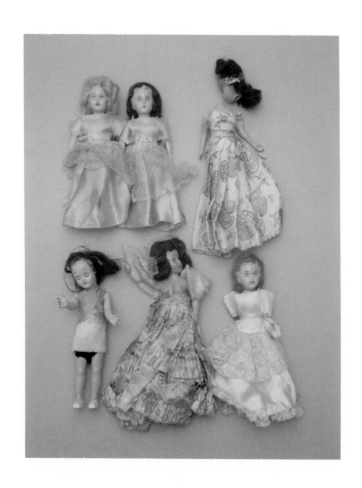

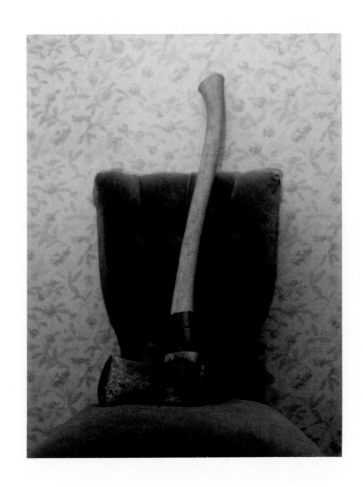

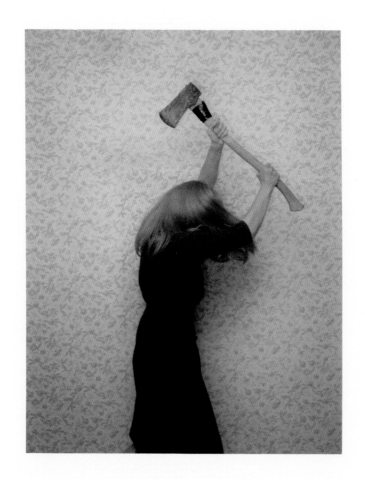

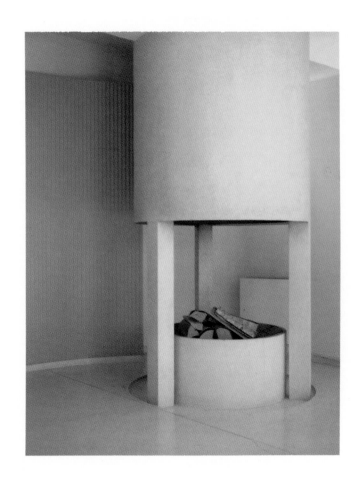

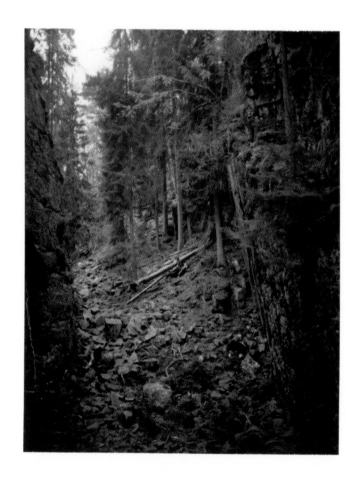

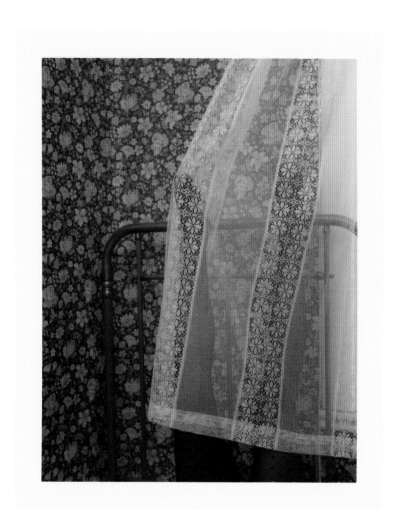

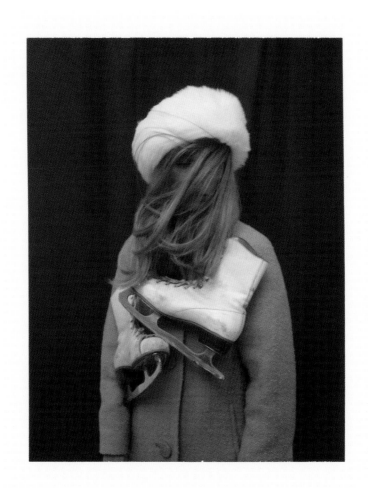

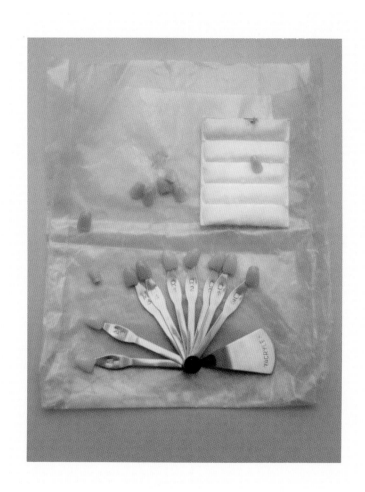

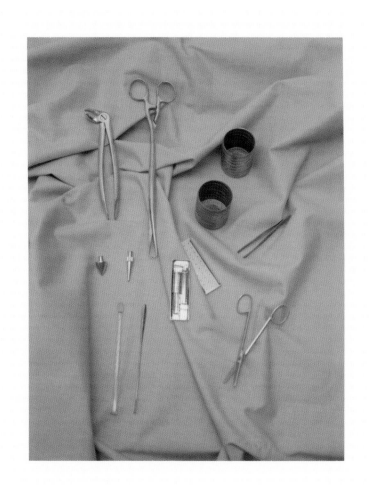

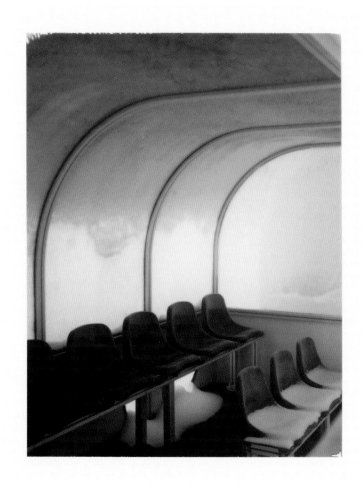

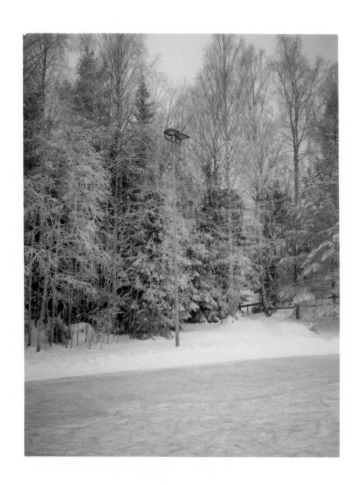

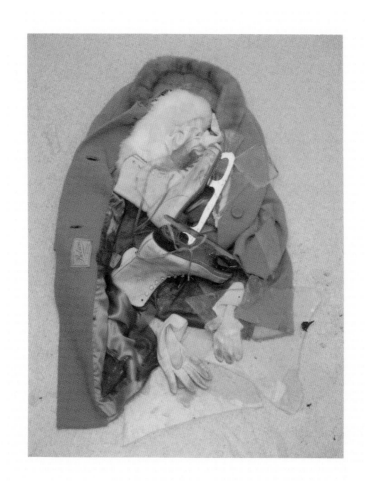

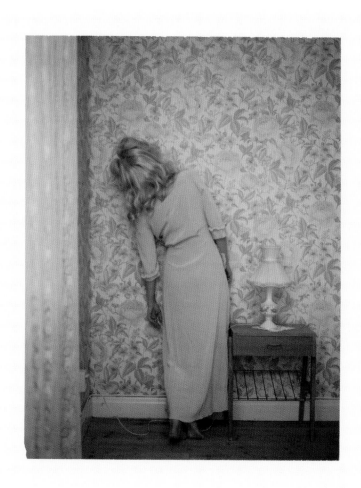

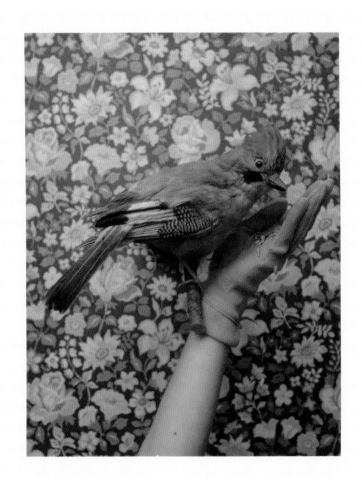

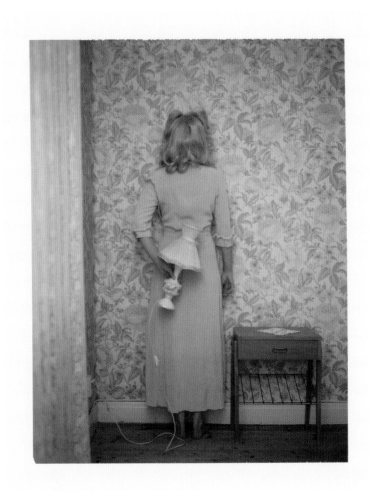

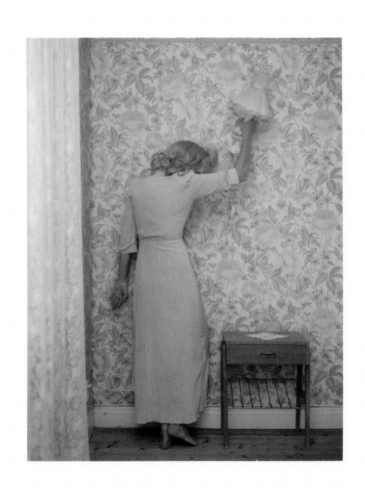

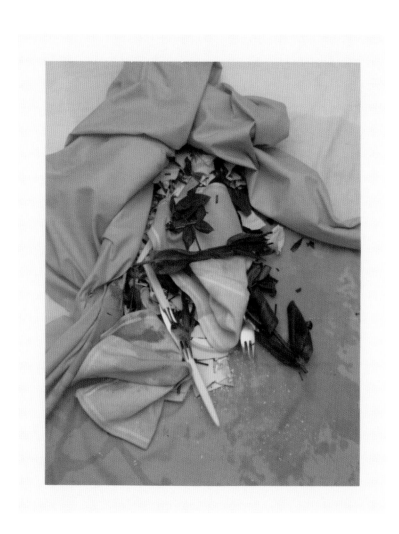

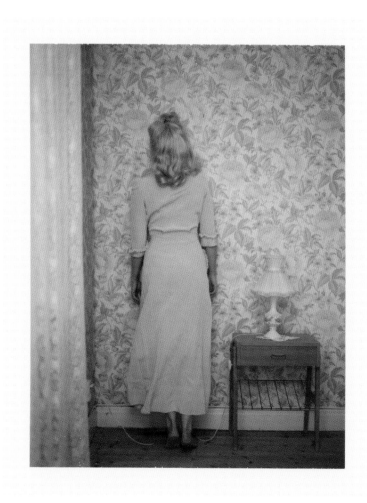

– V –

THE WOMAN WHO NEVER EXISTED

2017

INDEX

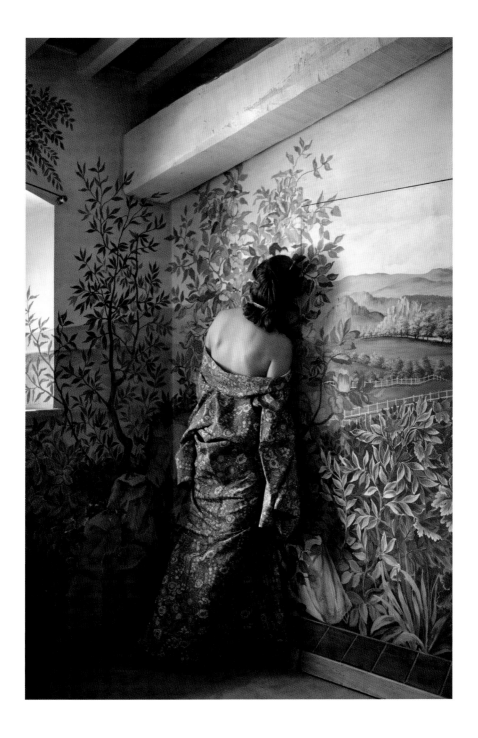

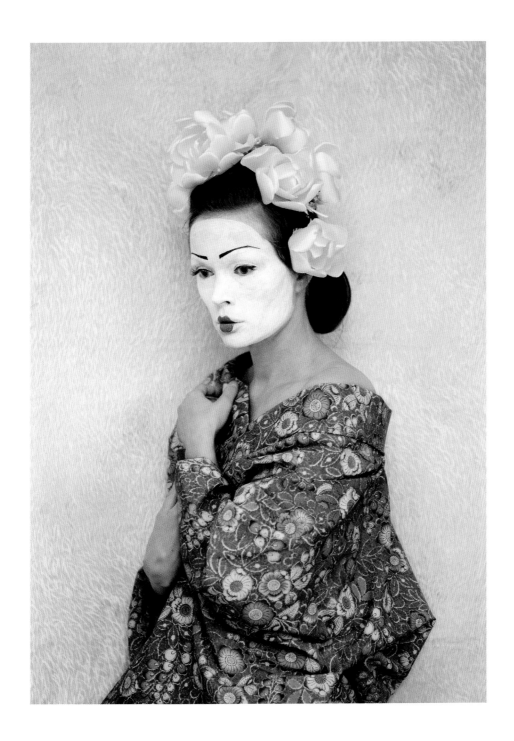

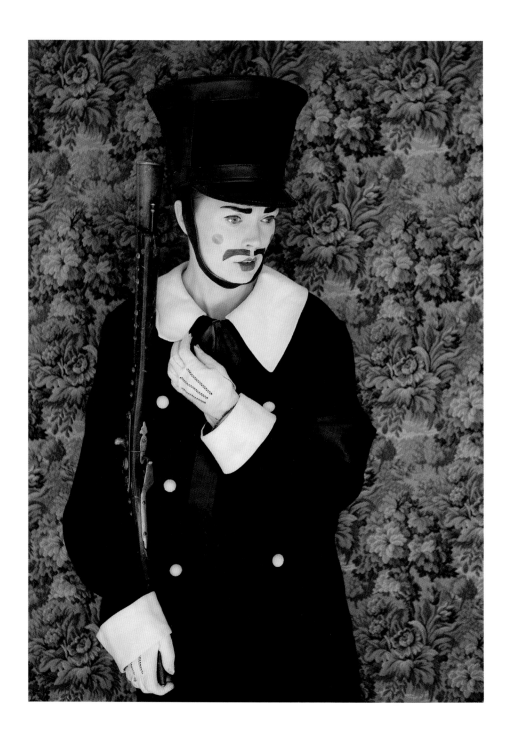

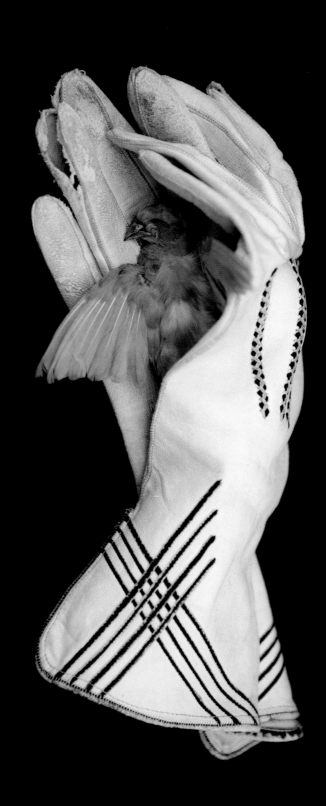

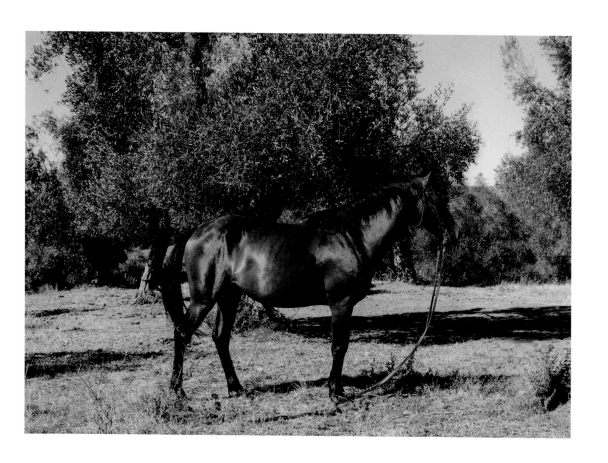

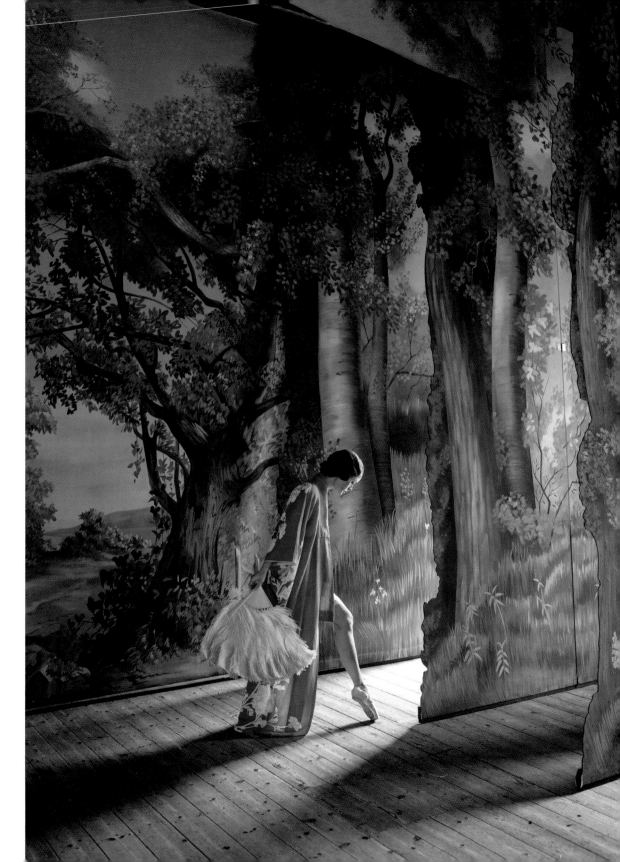

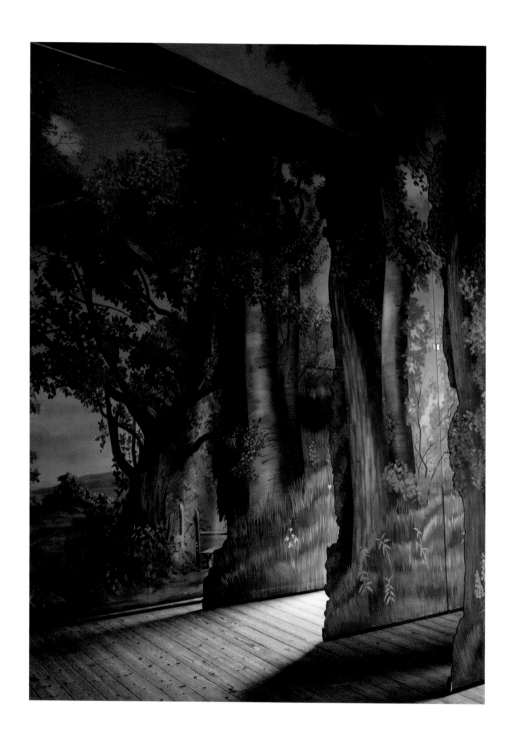

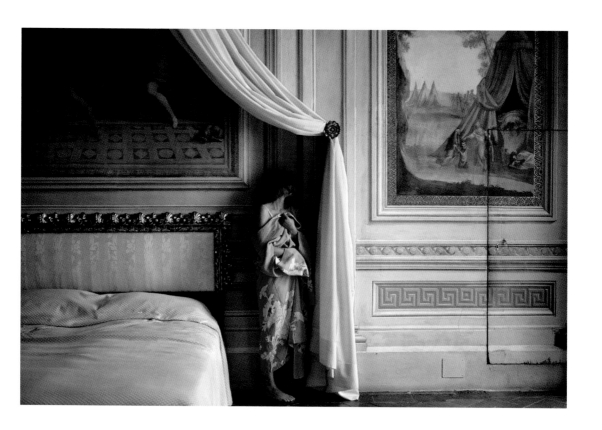

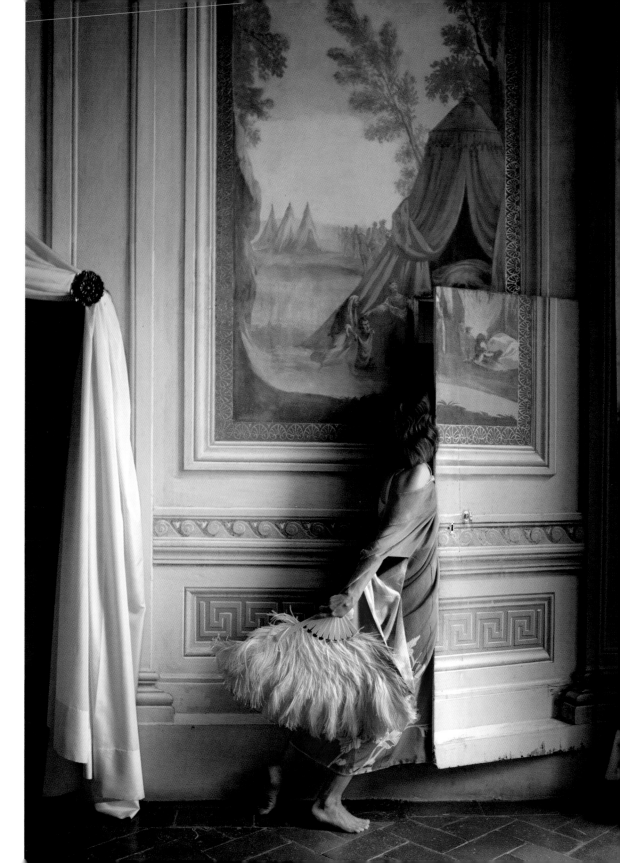

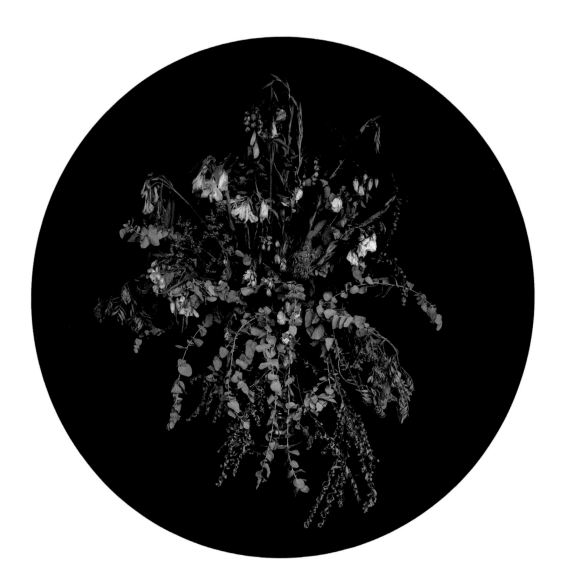

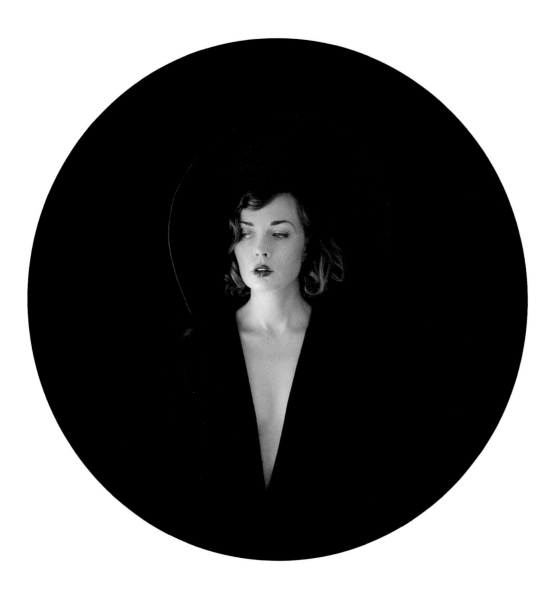

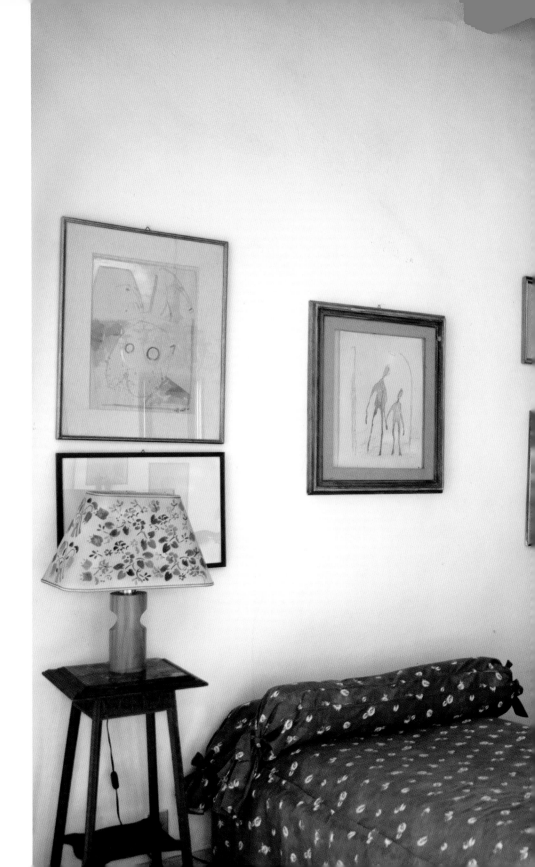

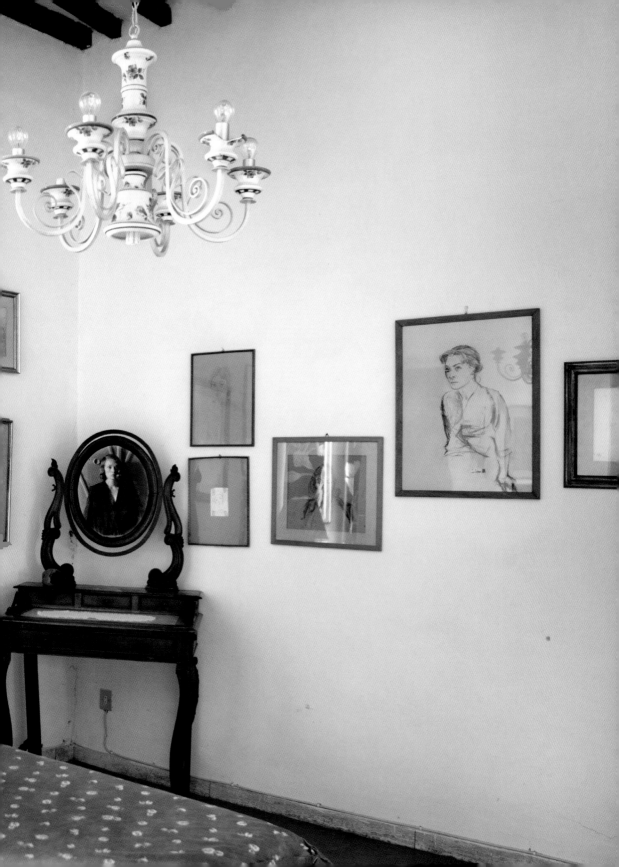

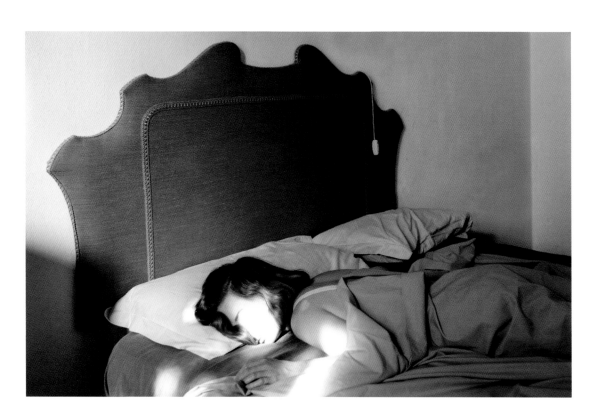

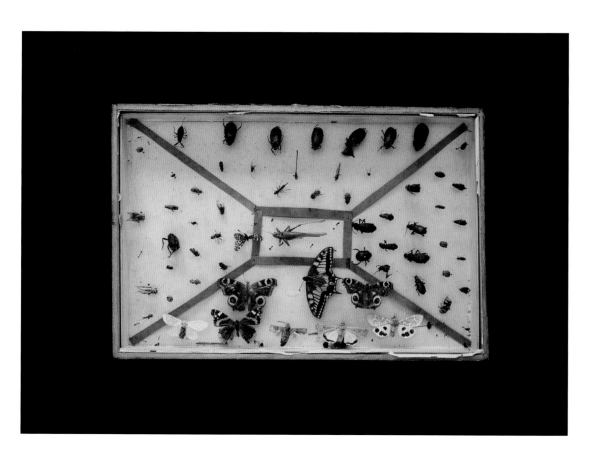

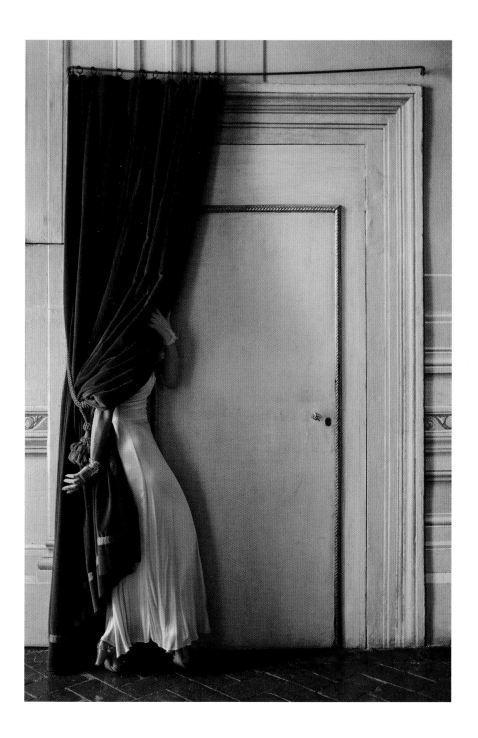

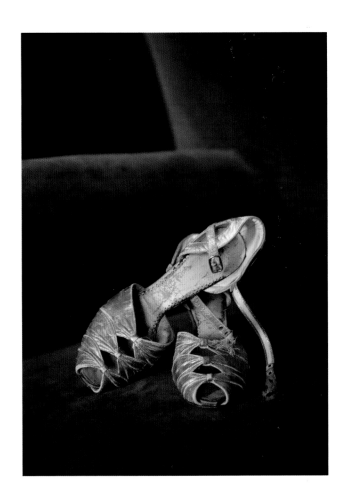

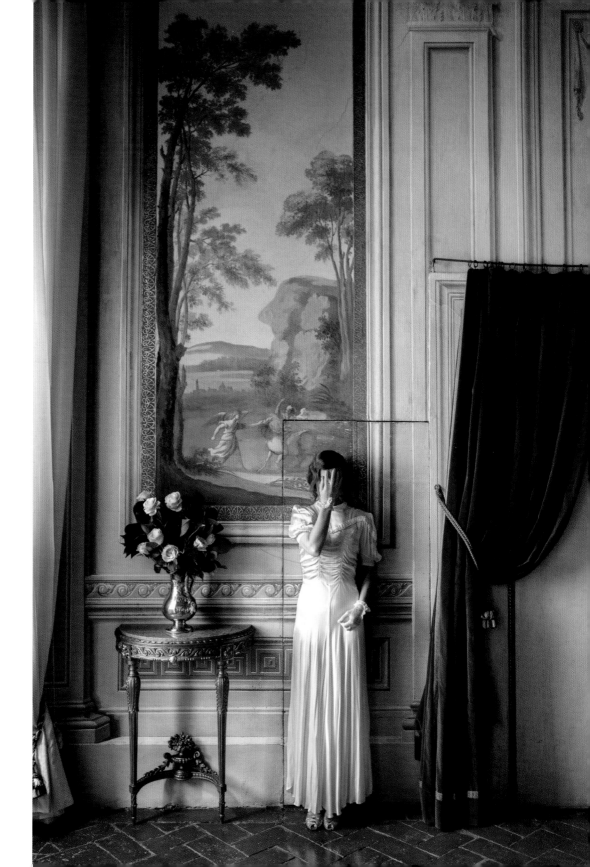

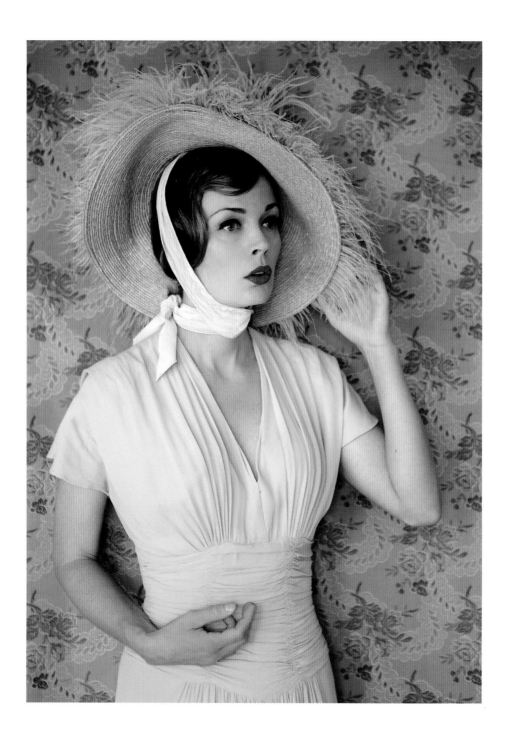

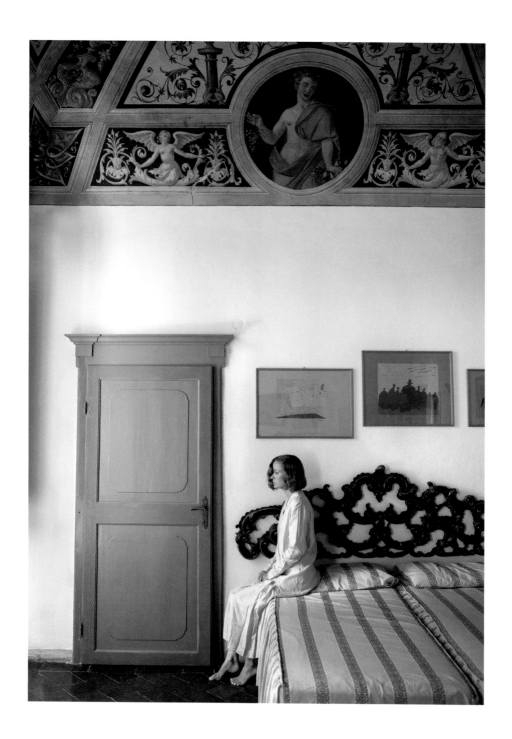

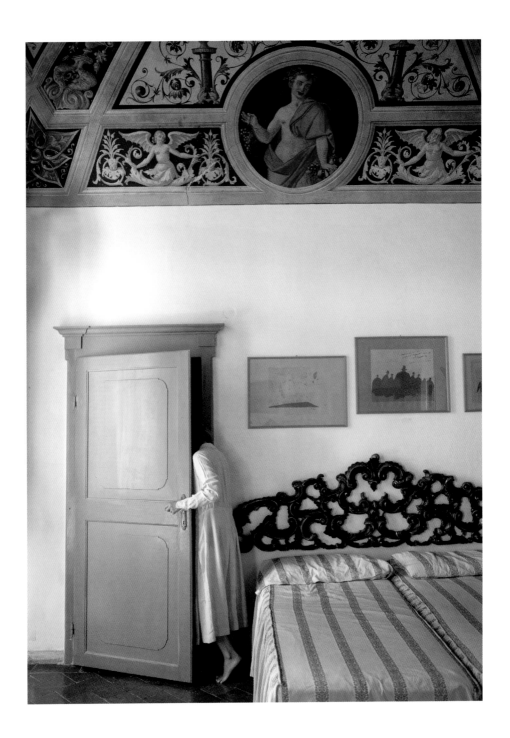

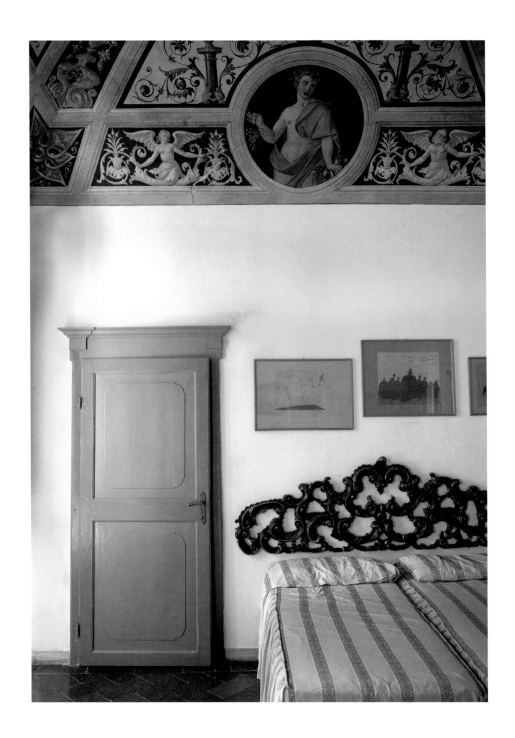

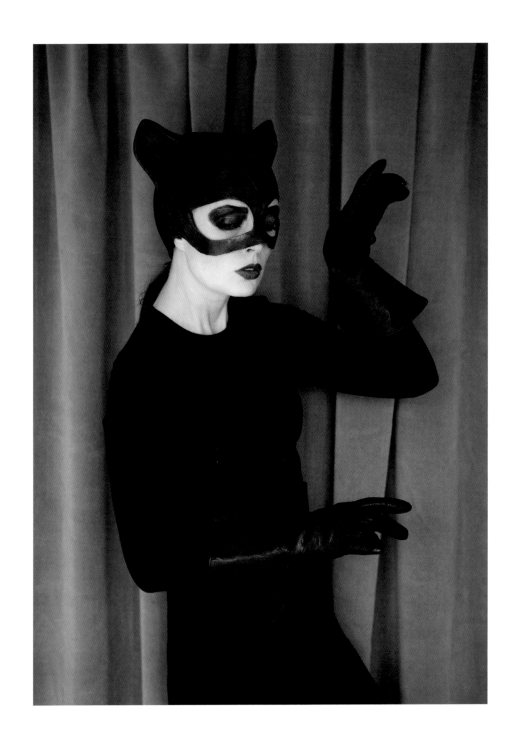

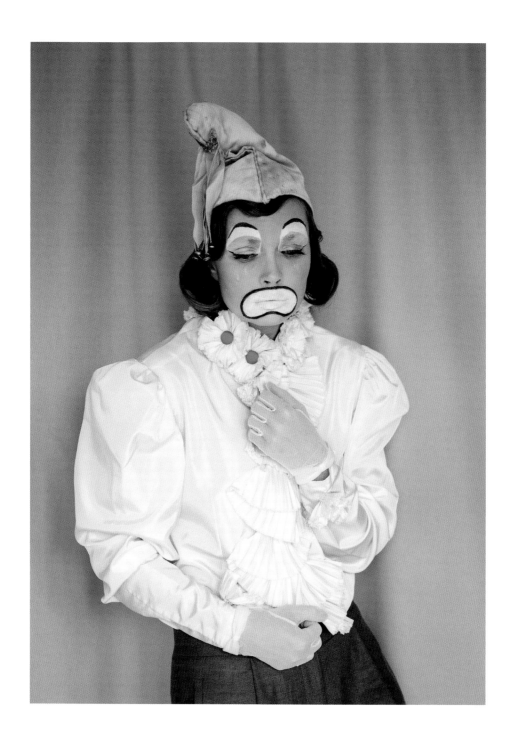

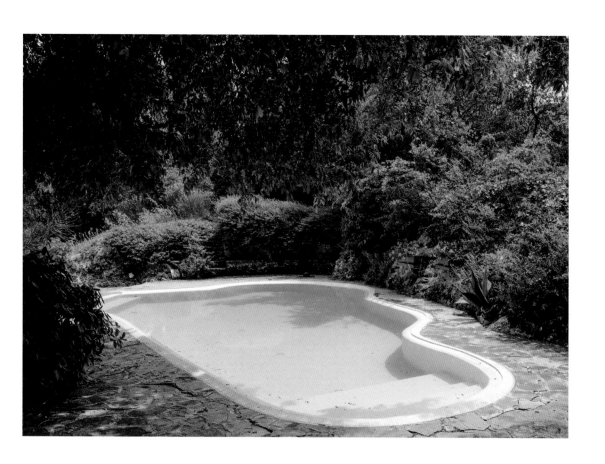

– VI –

SHE COULD HAVE BEEN A COWBOY

2018

INDEX

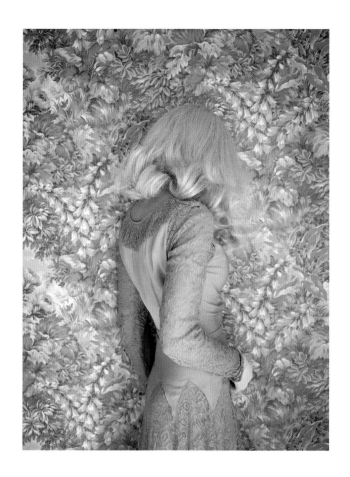

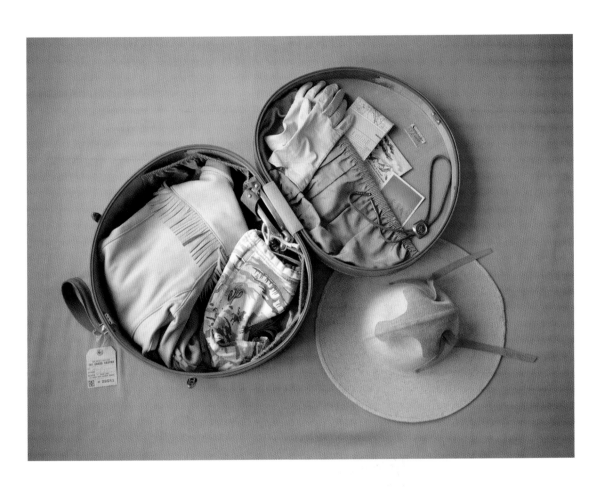

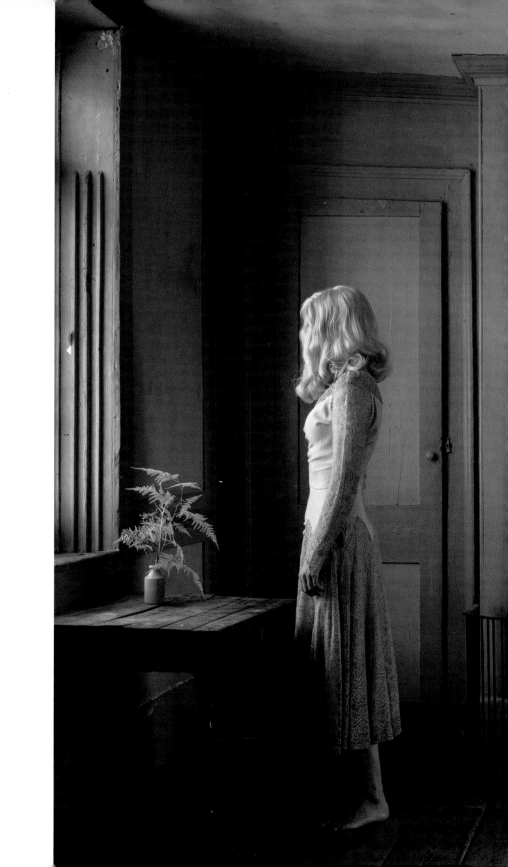

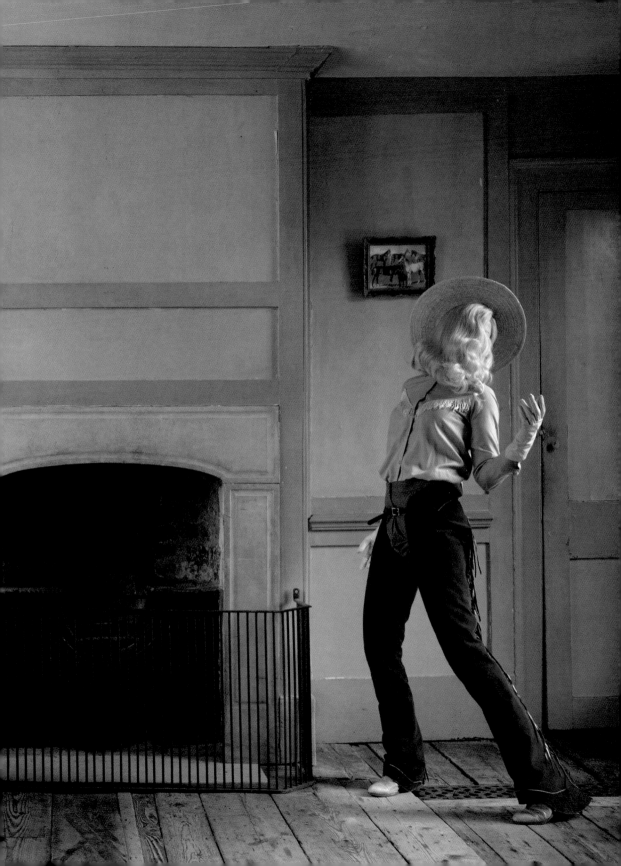

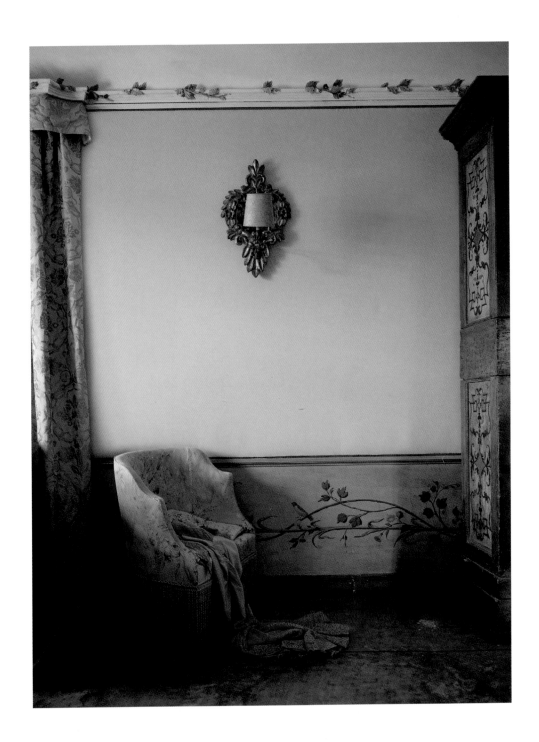

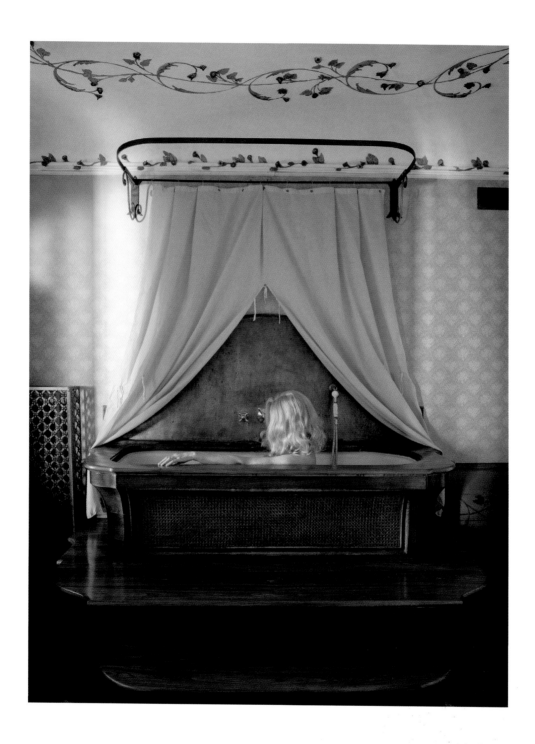

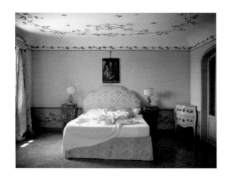 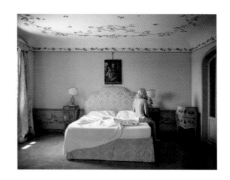

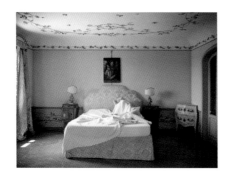 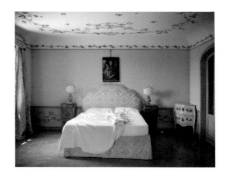

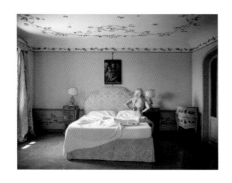 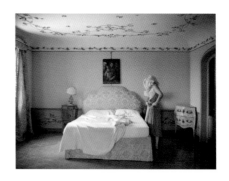

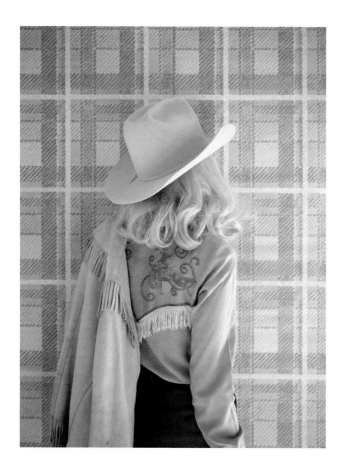

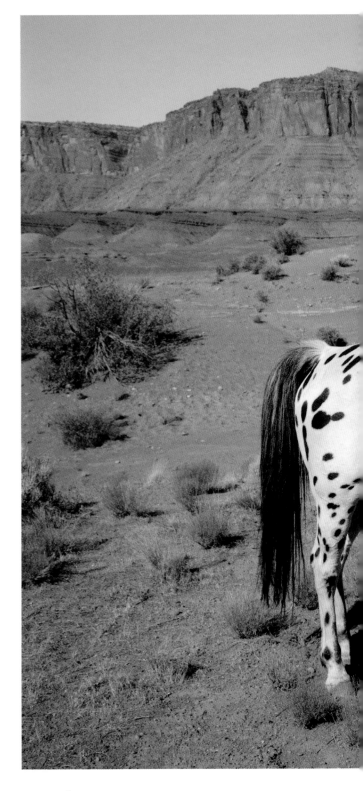

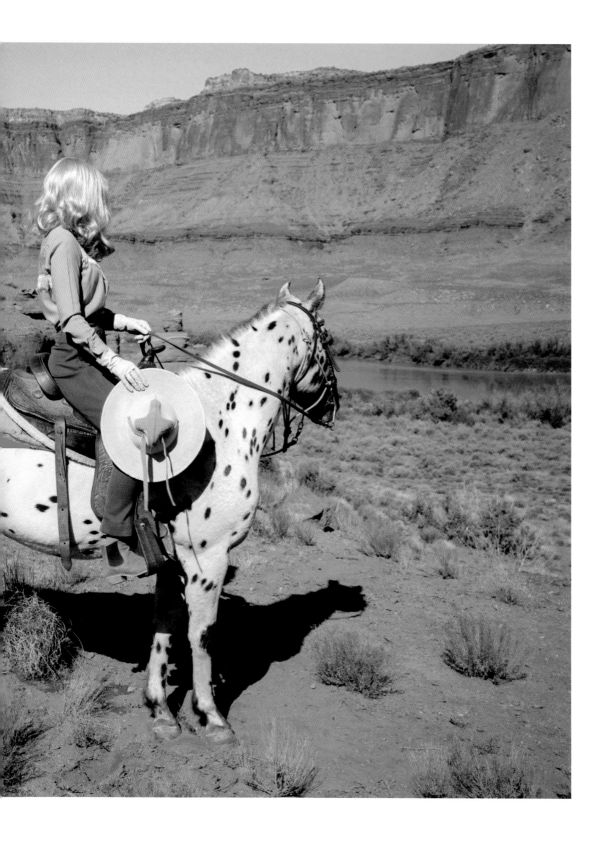

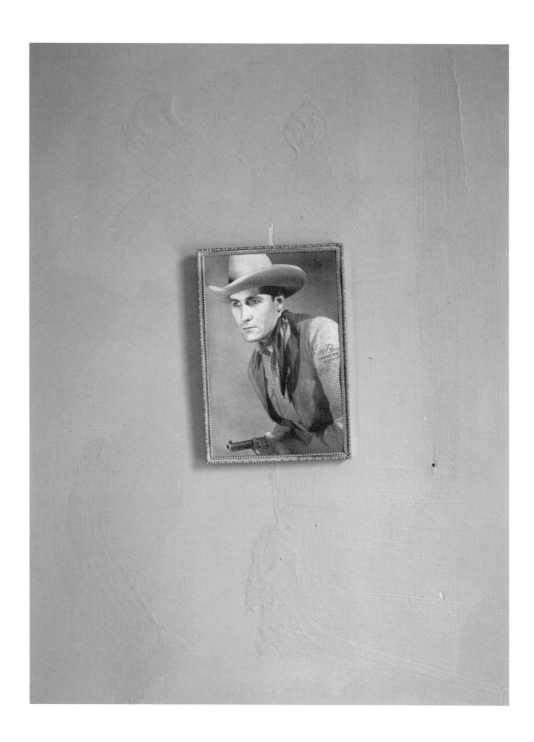

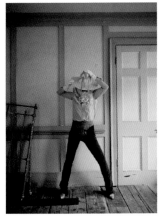
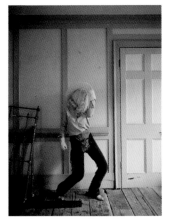
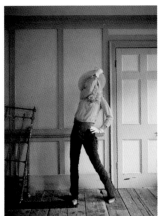
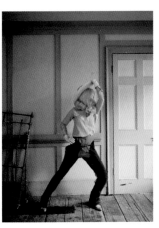
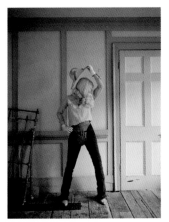
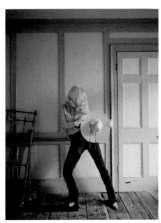
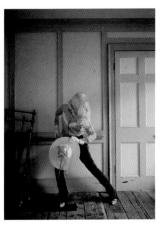
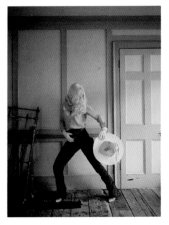
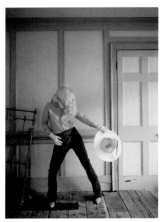

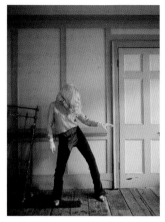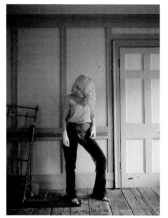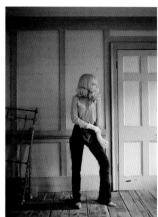
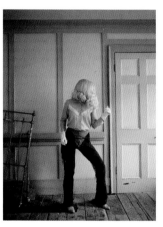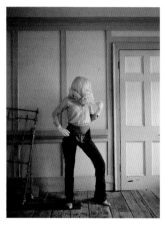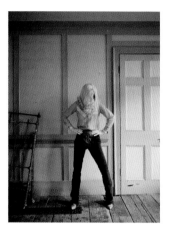
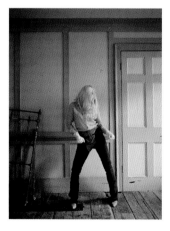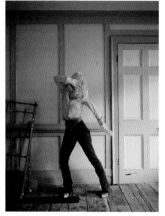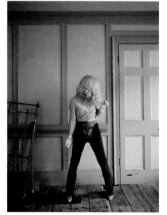

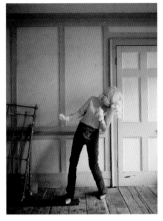
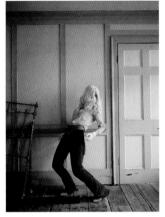
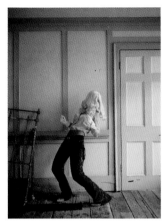
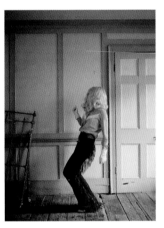
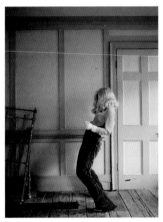
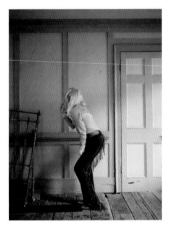
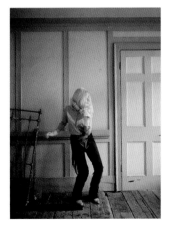
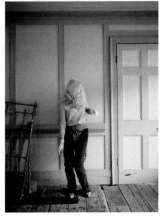
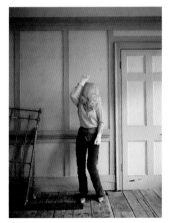

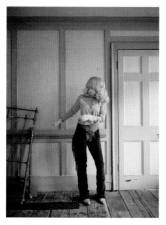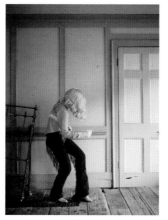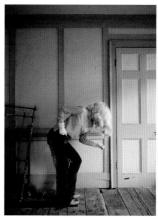
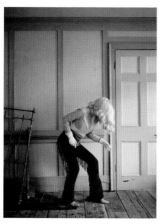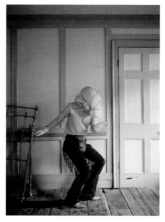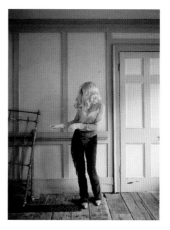
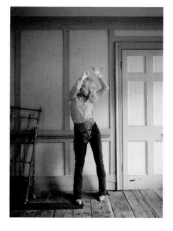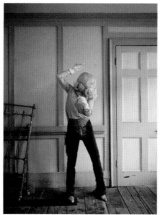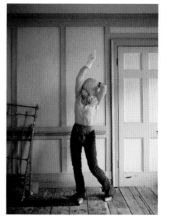

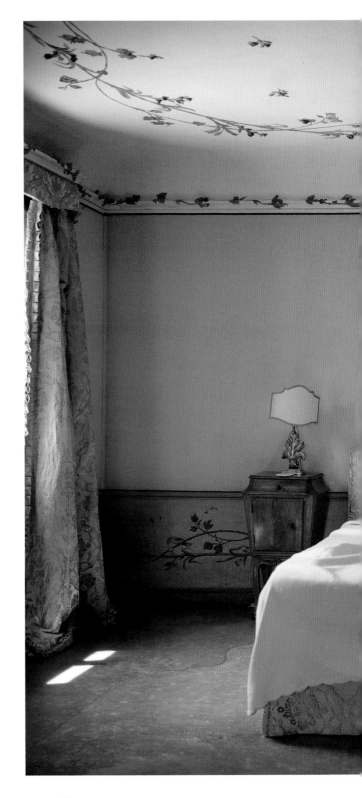

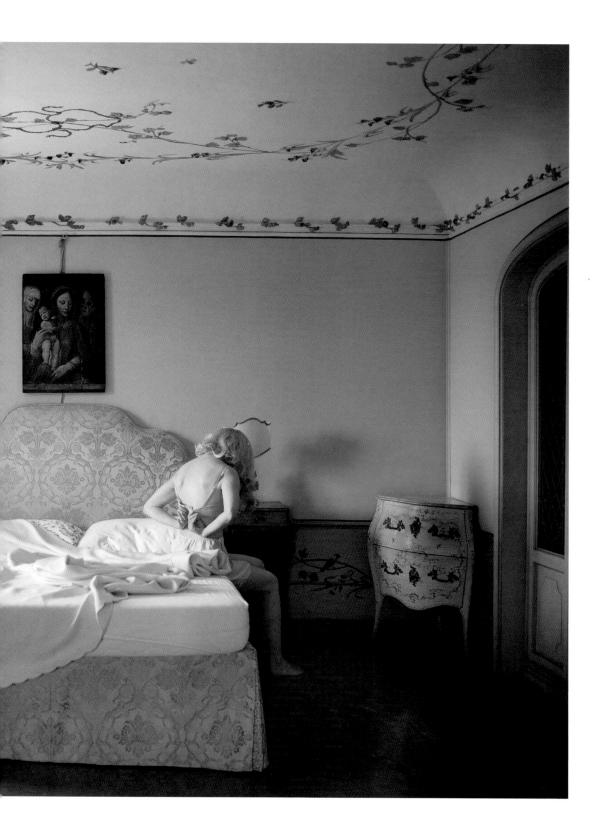

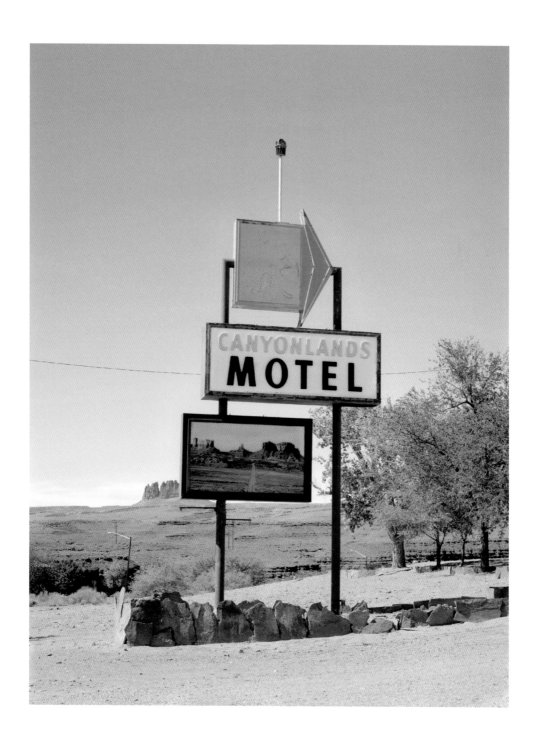

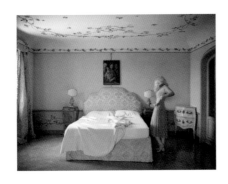

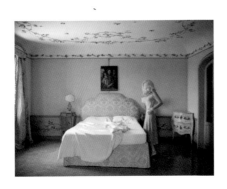

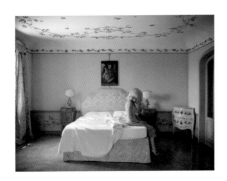

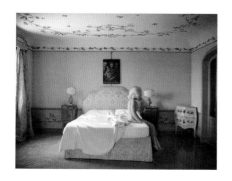
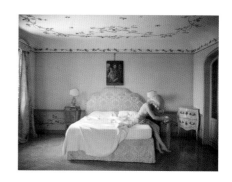
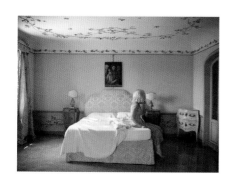
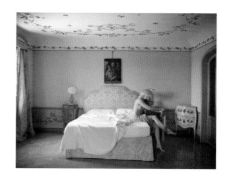
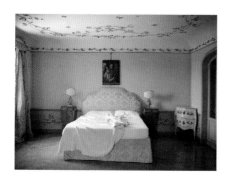
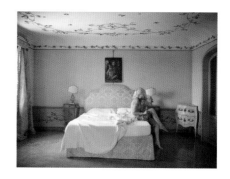

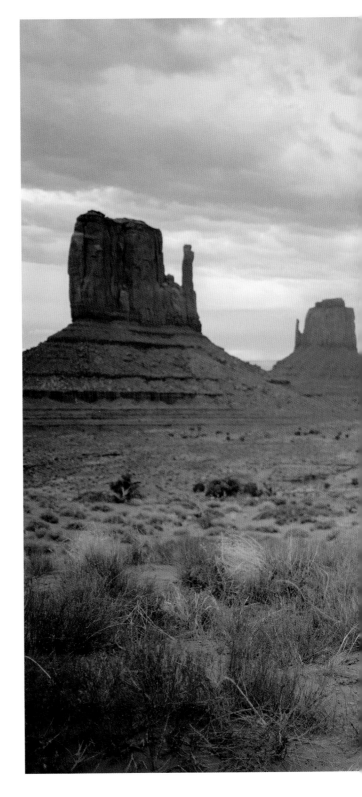

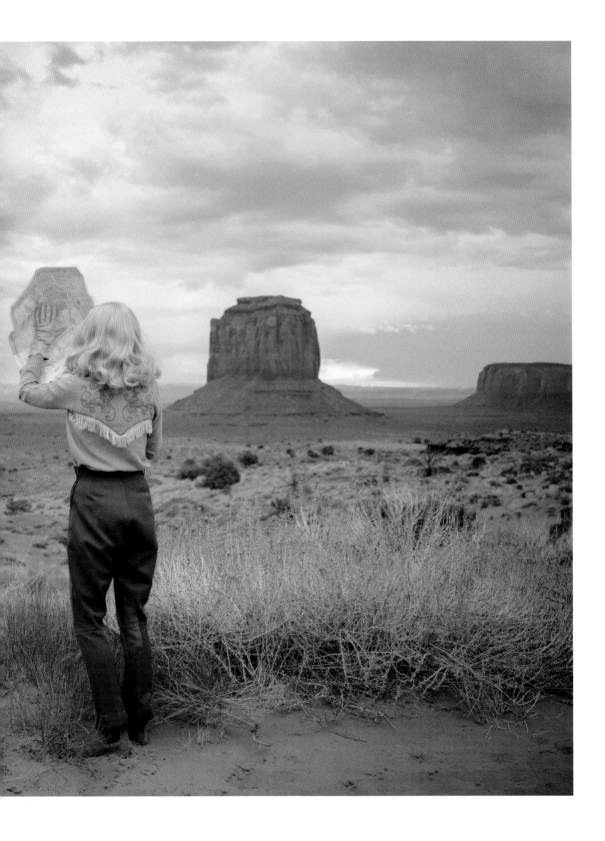

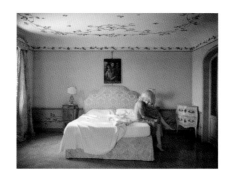

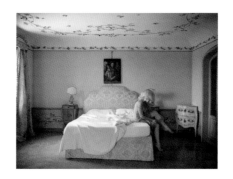

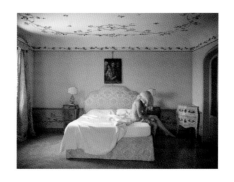

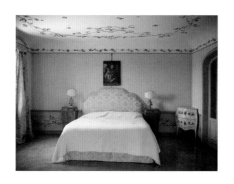

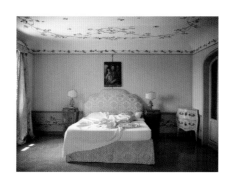

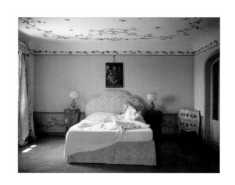

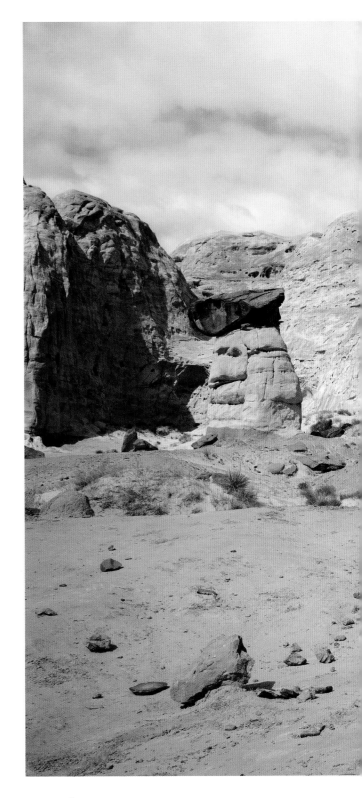

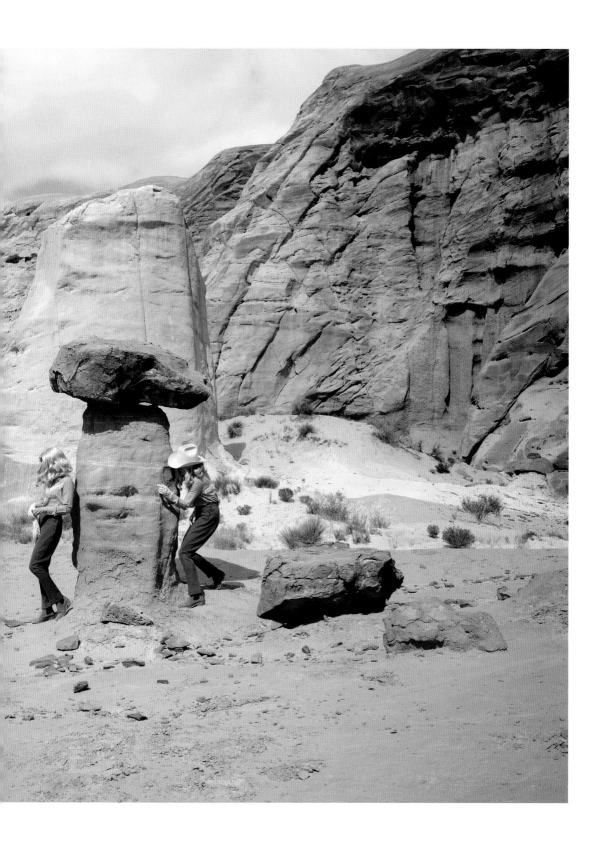

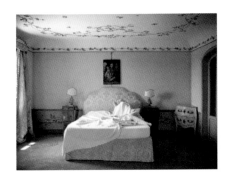

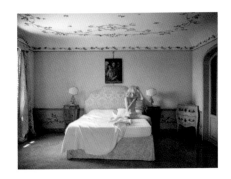

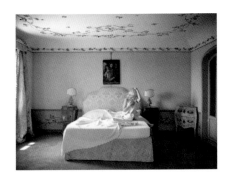

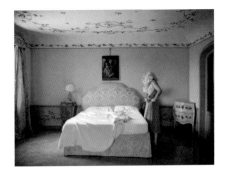

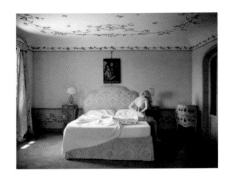

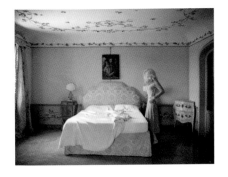

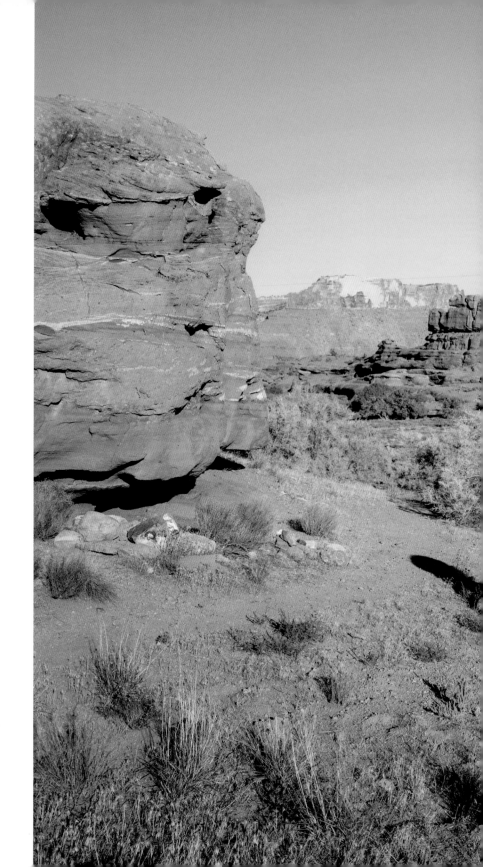

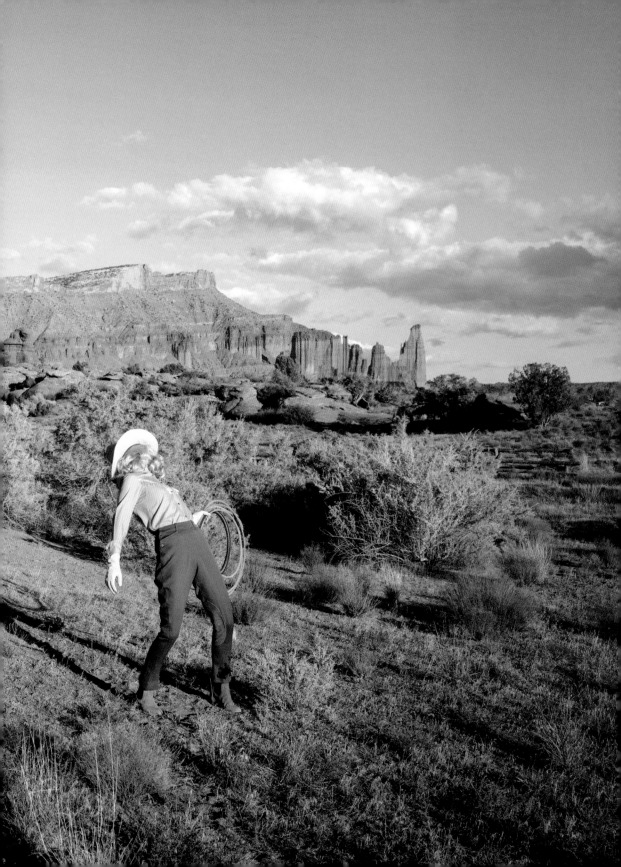

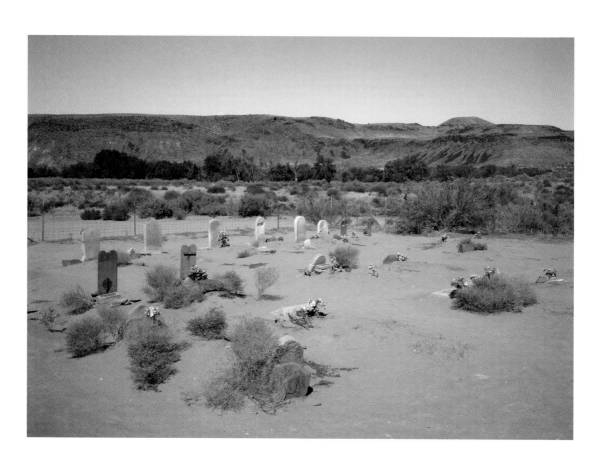

CONFUSION RANGE

WAH WAH MTs

SEAMAN RANGE

THE MAP

The route for
She Could Have Been A Cowboy

MEADOW VALLEY MTs

ST. GEORGE

MESQUITE

VIRGIN MOUNTAINS

GRAND
CANYON
PARASHANT
NATIONAL
MONUMENT

LAS VEGAS

HENDERSON

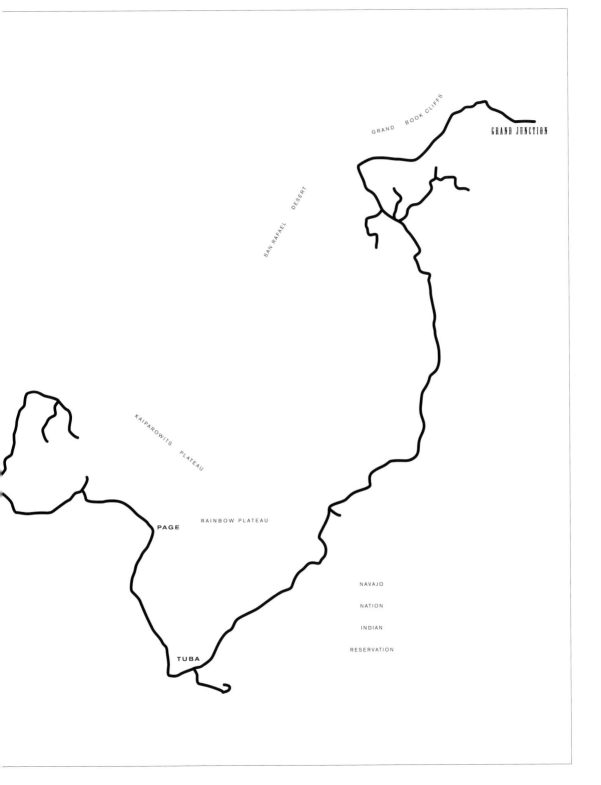

GRAND BOOK CLIFFS

GRAND JUNCTION

SAN RAFAEL DESERT

KAIPAROWITS PLATEAU

RAINBOW PLATEAU

PAGE

NAVAJO

NATION

INDIAN

RESERVATION

TUBA

ACKNOWLEDGMENTS

I would like to thank Andrew Sanigar, Sam Palfreyman and Ginny Liggitt at *Thames & Hudson*, Jeremy Kunze from *Studio Kunze*, Max Houghton, Ghislain Pascal and Tamara Beckwith Veroni at *The Little Black Gallery*, Narda Van 't Veer and Jasper Bode at *The Ravestijn Gallery*, Steven Kasher and Cassandra Johnson at *Steven Kasher Gallery*, Johan Vikner at *Fotografiska*, Helene Gulaker Hansen at *Shoot Gallery*, Valerie-Anne Giscard d'Estaing at *Photo12 Galerie*, Iris Fernandes and Terry Hack at *Bayeux*, Tim Blake at *Darbyshire*, *Norwegian Arts,* and a special thanks to my friends and family.

To Thomas, Edith and Lucy for all their love.

BIOGRAPHIES

Anja Niemi (b. 9 July, 1976) is a Norwegian photographic artist.

Max Houghton is senior lecturer in photography at London College of Communication, University of the Arts London. She writes regularly for the international arts press and is co-author, with Fiona Rogers, of *Firecrackers: Female Photographers Now* (Thames & Hudson, 2017).